DEGAS

Pastels

DEGAS

Pastels

by Alfred Werner

Watson-Guptill Publications/New York
Phaidon/Oxford

Front cover: *The Singer in Green*
The Metropolitan Museum of Art
Bequest of Stephen C. Clark, 1960

Paperback Edition, 1977

First published 1969 by Watson-Guptill Publications,
a division of Billboard Publications, Inc.
1515 Broadway, New York, N.Y. 10036

Published in the United Kingdom by Phaidon Press Ltd., Littlegate
House, St. Ebbe's St., Oxford

ISBN 0-8230-1276-X (U.S)
ISBN 0-7148-2369-4 (U.K.)

Manufactured in Japan

2 3 4 5 6 7 8 9/89 88 87 86 85

Foreword

Another book by Degas! For a reason, one may turn to the explanation given by Richard F. Brown, then Director of the Los Angeles County Museum, in introducing that museum's 1958 Degas show:

"The people of each succeeding period in time look at the art of the past with different eyes, and one might say that the art of the past changes as much as does the art of the present with every new creative contribution that is made in the present." He expressed the hope that through the exhibition, "our new eyes will be focused upon the great contribution which Degas made in his time, and that our appraisal of both the past and the present will be sharpened and deepened therewith."

While this book is limited to one segment of Degas' work, it has the same goal.

In recent years, there has been a "discovery" rather than "rediscovery" of Edgar-Hilaire-Germaine Degas. Not that he has ever been forgotten, nor that his fame has been eclipsed by that of other stars of his time—far from it. With the six other great participants in the revolutionary Impressionist group exhibition of 1874, he has been shown and written about unabatedly for almost a century. But in the last ten or fifteen years, certain aspects of Degas' work have been newly appreciated. While we still admire his oils, we now find them a bit drab compared to his pastels, especially the late ones that have more appeal to a generation dazzled since birth by the color explosion that began as Degas' active phase was ending. There has also been a new appreciation of his prints and of his three-dimensional work, in which we can discern the beginnings of abstraction. Rodin, who certainly never suffered from any underestimation of himself, once confessed that he considered Degas a "stronger" sculptor than he.

Some may agree with this judgment. And many of us will share the admiration which the great, yet humble, Pissarro had for his colleague and fellow "Impressionist," Degas. The two were friends—to the extent that anyone could call himself a friend of the haughty and irritable Degas—until L'Affaire Dreyfus created a gulf between the two. In a letter of 1883, Pissarro found it necessary to sell a pastel by Degas which he owned. "It will be painful to let it go," he wrote. "The more I think of it, the more mortified I feel about parting with the Degas . . . it means losing one of our purest joys."

It is significant that Pissarro cherished a pastel so highly. Deeply influenced by Ingres, Degas began as a linearist, but, unlike Ingres and his school, was profoundly moved by color. Since he could not accomplish with oils what he desired, Degas turned to pastel. This medium resolved his conflict between the linear and what Heinrich Woefflin was to call "the painterly"—pastel being, as it were, a bridge between painting and drawing. It allowed the artist to do one or the other, or both at the same time—and with the most splendid results.

This book does not include the master's earliest ventures into the genre of pastel, since they are still bound to the tradition of eighteenth century pastellists and are without any particular originality. The works begin with one of about 1873. (While most of Degas' important pastels are signed, few have a date on them. Therefore, the majority of dates are approximations established by scholars.) They range from what might be described as poetic Realism to Expressionist patches of color which anticipate by a few decades *tachiste* experiments. This volume includes several late works executed in the first decade of this century, shortly before even Degas' "good" eye had become too weak to see more than dim shapes.

Degas Pastels is limited to examples from public collections in the United States. Fortunately, this country is very rich in works by Degas—so rich, indeed, that even French books on the master *must* draw on items to be found on this side of the Atlantic. In 1929, when Mrs. Havemeyer bequeathed to the Metropolitan Museum of Art, New York, 43 paintings, pastels, drawings, and prints by Degas, along with 68 bronzes, she made this the largest Degas collection after that of the Louvre. In this book are such gems from this bequest as *The Rehearsal on Stage, At the Milliner's, Three Dancers Preparing for Class, Singer in Green, Woman Having her Hair Combed,* and *Woman Drying her Foot.* Other great examples of Degas' art in this volume (pastels that no anthologist would choose to omit) are *Two Dancers Resting,* The Museum of Fine Arts, Boston; *Before the Exam,* the Denver Art Museum; and *Three Dancers,* The Toledo Museum of Art.

I hope that this book will lead to a deeper appreciation of a master who defies all classification and who, ironically, was destined to help uproot the very traditions which he loved so much. When he was no longer a prisoner of exactitude, he produced those metaphors, glowing with color, that are counted among the finest and most lasting products of *la belle époque.*

To my wife, Judith Werner

Acknowledgements

My thanks go to a large number of authors—French, British, American, and German—from whose research I have profited, especially Jean Sutherland Boggs, Lillian Browse, Douglas Cooper, and Denis Rouart. The British painter Bernard Dunstan generously gave me permission to quote from his still unpublished English translation of Rouart's treatise on the technique of Degas. My special thanks go to Bradford D. Kelleher, Sales Manager, The Metropolitan Museum of Art, who first conceived the idea with my publisher; and to Joseph Veach Noble, Vice-Director for Administration, The Metropolitan Museum of Art, who lent his encouragement to the project. I am also indebted to Valia Hirsch and Fred Lida for their valuable aid. This book was suggested by Donald Holden, Editor of Watson-Guptill, to whom I am grateful for advice and help. I also wish to thank Judith Levy of Watson-Guptill, who carefully read and edited my manuscript.

Cooperating Museums

I would like to thank the staffs of the following twenty-one American museums, who supplied me with basic scholarly data and who made available their color transparencies—many of which were shot especially for this book.

Art Institute of Chicago
The Art Museum, Princeton University
Cincinnati Art Museum
City Art Museum of St. Louis
The Cleveland Museum of Art
The Columbus Gallery of Fine Arts
The Corcoran Gallery of Art
The Denver Art Museum
Fogg Art Museum, Harvard University
The Hill-Stead Museum
The Memorial Art Gallery of the University of Rochester
The Metropolitan Museum of Art
Museum of Art, Rhode Island School of Design
Museum of Fine Arts, Boston
The Museum of Modern Art
National Gallery of Art
Philadelphia Museum of Art
The Phillips Collection
Shelburne Museum
The Toledo Museum of Art
Wadsworth Atheneum

List of Illustrations

Chronology

1834. Edgar-Hilaire-Germaine de Gas, born in Paris on July 19, the eldest of five children of a banker (the artist was to sign his name "Degas").

1845. Enters the Lycée Louis-le-Grand, Paris.

1853. Finishing his classical studies, he passes his baccalaureate examination and registers in the Faculty of Law, Sorbonne.

1855. Under Louis Lamotte, an erstwhile disciple of Ingres, studies drawing at the Ecole des Beaux-Arts, Paris. Meets Ingres.

1856-57. Travels in Italy where he copies the old masters.

1862. After a visit to a friend's estate in Normandy, begins to draw and paint pictures of riders and horses.

1866. Stops painting historical topics and turns to portraiture.

1867. Exhibits in the Salon: two family portraits.

1868. *Mlle. Fiocre in the ballet 'La Source'*, his first major work on the ballet theme, is exhibited in the Salon.

1869. Produces his first important pastel, a portrait of his sister Thérèse. One of his canvases is rejected by the Salon.

1870. His last participation in the Salon. In the Franco-Prussian war he serves in the artillery under his friend, the painter Henri Rouart. Beginning of eye trouble.

1871. Escapes from the terror of the Commune to Normandy.

1872. Accompanies his brother René to the United States, spending several months in New Orleans where his brothers René and Achille are cotton merchants. He paints *The Cotton Market*, his first work to be acquired by a museum.

1874. Paints scenes of everyday life and pictures inspired by observations at the Opera. Associates with several progressive artists who, like Degas, are dissatisfied with the reactionary standards of the official Salon, and who meet regularly at a café. Active in *La Société Anonyme des Artistes Peintres, Sculpteurs et Graveurs, etc.*, that becomes known popularly as the Impressionists. Participates in the group's first show at the studio of the photographer Nadar on the Boulevard des Capucines.

1875. Obliged to sell many of his Old Master works to help his brothers out of financial difficulties.

1876, 1877, 1879 and 1880. Participates in the second, third, fourth, and fifth Impressionist shows.

1880. Trip to Spain.

1881. His wax statue of a fourteen-year-old dancer is included in the sixth Impressionist show.

1882. Travels to Spain and Switzerland. Does not enter the seventh Impressionist show.

1883. Exhibits seven canvases in London.

1886. Visits Naples. Exhibits his works in the eighth and last Impressionist show, Paris, and in a New York exhibition of French art organized by the dealer Durand-Ruel.

1889. Visits Spain and Morocco.

1890. Journeys to Burgundy with the sculptor Albert Bartholomé.

1892. Shows pastel landscapes at the gallery of Durand-Ruel.

1893. From the legacy of the painter Caillebotte, Degas' pictures are accepted by the Luxembourg Museum, Paris.

1897. Makes a pilgrimage to the Ingres Museum at Montauban, near Toulouse, in Southern France.

1900. In the Paris Centennial Exhibition, he is represented with two oils and five pastels.

Ca. 1905. His sight failing, he more or less abandons drawing and painting, and concentrates on small sculpture.

1912. After the death, of Henri Rouart, the Rouart collection of works by Degas is put on public auction, and one picture brings an enormous price (435,000 francs). On the demolition of the building in the rue Victor-Massé, where Degas had lived for over twenty years, he moves to the Boulevard de Clichy. He now stops work completely.

1914. The collection assembled by Isaac de Camondo, which contains major works by Degas, is bequeathed to the Louvre.

1917. On September 27, Degas dies in his bed. The simple funeral is held on September 29 at the Church of St. Jean-Baptiste de Montmartre, and his body is buried in the family vault in the Montmartre cemetery. President of the French Republic sends a representative to express the nation's gratitude and admiration.

DEGAS

"If Degas had died at fifty, he would have been
remembered as an excellent painter, no more;
it is after his fiftieth year that his work broadens out and
that he really becomes Degas."

Renoir, as quoted by Vollard

Who was Degas? After studying all the accessible books about him and his work, one dares not assume that one knows, at last, this strange man—this "old curmudgeon," as the novelist George Moore characterized him. We remain baffled despite the fact that only a little more than half a century has elapsed since his death, and notwithstanding a literature too large to be accommodated in one room: the memoirs of various authors, dealers, models, and, of course, fellow artists, as well as many volumes by historians and critics.

"The artist must live alone, and his private life must remain unknown," Degas insisted. Unlike Van Gogh, he has left us relatively few letters, none very long, and none that probe deeply into his inner self. From Delacroix, we have extensive journals, many letters, and even a number of polished essays. Degas, though as highly cultured and as capable of literary expression, confined himself (apart from some entries into notebooks and a few sonnets) to oral statements, many of which have come down to us in several variant versions. They reveal a sarcastic wit, a razor sharp penetration and intolerance of sham, and an abrasiveness that contrasts with the tender lyricism of much of his work. Some of these barbs approach the utter limits of realism, and at times appear cruel.

THE TERRIBLE MONSIEUR DEGAS

At some point, then, we must choose whether we are to view Degas as a near monster, whose sharp tongue inevitably wounded anyone who would come close—perhaps too close—to him; or we may see him as a basically harmless, yet overly sensitive artist who deliberately antagonized people and willfully cultivated the image of "that terrible Monsieur Degas" to make sure that society would not dare disturb his treasured solitude and take from him the only possession that mattered, time for working.

This is not to deny that he was a difficult person, nor that he was full of many prejudices. He broke with his Jewish friends at the time of the Dreyfus case. He fired a model upon learning that she was a Protestant. A staunch reactionary in all political matters, Degas certainly did not believe in the emancipation of women, and was pained even to concede to himself that the artist Mary Cassatt had talent, in addition to feminine charm: "I will not admit that a woman can draw so well!" he remarked about her. He was, in short, adamantly opposed to all social reform, hostile to most technical innovations (such as the telephone), and even averse to children, dogs, flowers.

But again, on the internal evidence of his work, it is impossible to regard these foibles, or certain of his nastier utterances, as anything more than the neurotic quirks of a genius, embittered and unjust at times, but not motivated to inflict any real damage. After

all, Degas was an *uomo universale*, in the sense that the term is applied to some of the great masters of the Renaissance; and an idealist who sacrificed friendship, love, the blessings of family life on the altar of his art.

Professional artists, as a rule, are the busiest of men—Degas was the busiest of them all. He toiled and toiled; he felt "guilty, stupid, worthless" when he had not fulfilled his daily stint. Indeed, hardly any other artist of his time was as persevering, as strict with himself as he. "When I die, they will see how hard I worked." His estate contained thousands of works in different media, and, incidentally, yielded a fortune to his heirs, a brother and a niece. But Degas was concerned with neither money nor fame—only with perfection and purity. It is, therefore, not astonishing that his output, in a great variety of media, should be as vast as it is, enough to fill a good-sized museum.

THE DRAMA OF AN UNEVENTFUL LIFE

Although, at one point in his life, Degas drudged harder than ever to help his brothers after a sudden financial emergency, strictly commercial considerations played a very small part in his long life. Edgar Degas was the scion of a wealthy family and never in the degrading state of poverty that some of his associates (such as Monet, Pissarro, or Renoir) were to experience. Yet he was frugal. His bachelor lodgings, while spacious, were ascetically furnished. Few friends and no journalists were allowed to visit him there. Except for the model and the artist's dealer, scarcely anybody made the wearisome trip up to his studio.

Degas was born in Paris and died there. He rarely stepped outside what is now the Ninth Arrondissement, which includes, of course, his beloved *Opéra*. The only luxuries he allowed himself were frequent travels—which suited his restless personality—and the purchase of works of art.

If a life can be called uneventful, his might be. Its only dramatic element was his obsessive fear of losing his eyesight: There were none of the tempestuous love affairs that one encounters in the lives of so many artists. True, he so often sought out the company of women (of all varieties) that one hesitates to accept the epithet, "misogynist," fastened upon him by his biographers. But it is not certain that he ever fell in love. If he did, this most secretive of men certainly managed to conceal this from his many acquaintances and even from his few friends. He himself succinctly summed up his life when, as he became aware that death was approaching, he instructed his disciple, Jean-Louis Forain, that if there had to be a funeral oration, it should be limited to one sentence: "He greatly loved drawing." There was none at the Montmartre Cemetery, where only a few gathered to see his coffin lowered into the grave.

Oddly enough, we find it hard to imagine Degas as a young man. Yet he was not always an old codger. From photographs and self-portraits, we know him to have been a handsome, well built fellow of distinguished bearing. While never what his grandnephews would today call a "swinger," he was not always ungregarious. He attended the sessions of the Impressionists at their favorite cafés. He often went to the *cafés-dansants*, the circus, the theatre. And, of course, he regularly attended the opera. Even as a middle-aged, and finally old man, he walked very erectly. He hid behind a beard and often wore dark glasses to rest his tired eyes. He always dressed carefully, yet unostentatiously. Without having been stuffy, he must have impressed all as the person of aristocratic descent that he really was. While his father and his brothers continued to write "De Gas," the painter preferred a more bourgeois spelling of his name.

DEGAS AND THE IMPRESSIONISTS

He was one of the seven who, in 1874, ushered in a revolution that came to be known as Impressionism. In addition to him, the major figures in the first group show of the *Société anonyme des artistes peintres, sculpteurs, graveurs, etc.,* were Monet, Renoir, Pissarro, Sisley, Cézanne, and Berthe Morisot. Degas was the one with the greatest prestige (which he evoked in vain to persuade his friend Manet to join this gang of anti-*Salon* rebels). He received some of the critical abuse unleashed on this group of innovators; but, being closer to tradition than the others, he was, on the whole, much less attacked than, for instance, Monet. He remained with this association until it quietly dissolved after twelve years. In all that time, he failed only once to participate in their group shows.

His own aesthetics had only the most tenuous links to that of a Monet or a Pissarro. True, he shared their insistence on realism, their rejection of the notion of "ideal beauty," and their preference for what his erstwhile idol, Ingres, would have considered "vulgar" subject matter. Like them, he was more interested in the pulsating life around him than in the narratives relating to history or mythology so beloved by Academicians (and which he, himself, illustrated in his early years). He, too, enjoyed seizing an ephemeral event—the gesture of a bather, a singer, a laundress, a customer in a millinery shop, or a jockey mounted on a racehorse—and setting down the fleeting moment in all its fascination.

But he did not care for the Impressionists' "spectrum palette," composed of pure, bright, prismatic colors of refracted sunlight. He was not much attracted by landscape as a subject. He loathed open-air painting. All his work, except the most preliminary sketching, was done in his studio, and he even delivered a diatribe against *plein-airistes*. "You know what I think of people who work

out in the open. If I were the government, I would have a special brigade of gendarmes to keep an eye on artists who paint landscapes from nature. Oh, I don't mean to kill anyone; just a little dose of bird-shot now and then as a warning" (quoted by his dealer, Ambroise Vollard).

Even as a person, he was totally different from the other Impressionists, most of whom were married and had children. He was the very opposite of Renoir, who thoroughly enjoyed life, and who enriched the world with pictures of cheerful, buxom girls; gay, popular gatherings; and lush flowers. He was close only to one, who was also unmarried, and who at least came from an upper middle-class milieu—the American, Mary Cassatt. While there was no question of a love affair, to her he could talk freely—certainly more freely than to anyone else. Of those who considered themselves in some way his disciples (Jean-Louis Forain, Henri Toulouse-Lautrec, and Suzanne Valadon also spring to mind), Mary was closest to him.

A strange man, yet he does not seem to have been desperately unhappy as long as he could watch that artificial world of equipages and horse-races, *La Vie Parisienne*, could accompany female friends to the milliner's, or, furtively, could proceed to the bordellos (strictly, it seems, in the role of observer).

HIS FAILING SIGHT

He began to worry about his vision long before he turned forty. The origin of his eye troubles is not clear. In 1870 (during the Franco-Prussian war) he enlisted in the infantry and was sent to Vincennes for rifle practice. There it was discovered that he could not see the target with his right eye, and was turned over to the artillery, where acute vision was not deemed essential. He claimed to have injured his eyes by a chill caught in his nights as a sentinel during the siege of Paris. He may, indeed, have contracted conjunctivitis. The fact remains that his "good" left eye deteriorated over the years, and that in his old age "he could see only around the spot at which he was looking, and never the spot itself," we are told by his friend, the painter Walter Richard Sickert. While his eye troubles alone do not explain his switch to pastel, his condition probably persuaded him that this flat medium would be more suitable for him than the shiny one of oil.

When even work in pastels became extremely difficult, he turned to sculpture, producing small figures of dancers, horses, and horses with jockeys. At sixty-nine, he wrote to a friend: "I am always working with wax" (though, four years later, he was still drawing and making pastel sketches, according to a statement of his own).

He feared only one thing. Ordinarily so reserved, he exclaimed in the presence of a model: "God! Do not let me become completely blind; I would prefer death!" But eventually his vision became so poor that he had to stop working. For five long years, he could do nothing but idly wait for death to rescue him.

His dealer, Ambroise Vollard, was later to recall that "He now [from 1912 onward] spent his days wandering aimlessly around Paris, wearing a bowler hat, green with age, and enfolded in his inseparable Inverness cape. His eyes were getting worse and worse, and he had to take a policeman's arm when he crossed the street. Always as though lost in some dream, he would inquire, 'Oh, that war?' [the First World War] . . . In this final period of his life, as he roamed about, people likened him to King Lear."

FAME WITHOUT FORTUNE: THE FINAL YEARS

In 1912, the oil *Dancers Practicing at the Bar* (painted ca. 1876-77, and acquired by The Metropolitan Museum of Art in 1929) was bought by Mrs. Henry Havemeyer at auction for the then fantastic amount of 435,000 francs—approximately $700,000 today. It was the highest sum then ever paid for a work by a living artist. Ill-humored, Degas, who had originally sold the work for 500 francs (then the equivalent of $100), observed: "I feel like the horse which, having won the Grand Prix, receives merely his ordinary feed of oats." He was bitter that so many people were profiting from the resale of works that often had yielded him only a pittance. In 1965, the Parke-Bernet Galleries, New York, auctioned off a pastel owned by Mrs. Havemeyer's grandson to a California collector for $410,000. Mrs. Havemeyer had acquired it in 1873, also for 500 francs.

LAST OF THE OLD MASTERS, OR PRECURSOR OF ABSTRACT ART?

Today, there is less demand for his work in oil, which "begins to wear a somber, mid-nineteenth century look," (Gerald Reitlinger in *The Economics of Taste*). Still, his oils of the seventies far surpass what was produced and often rewarded with gold medals by *Beaux-Arts* professors. It cannot be denied that Degas was a fine painter, and above all, a stunning portraitist, whatever medium he used. On closer scrutiny, even some of his "somber oils" point to the future.

Degas' non-centralized composition, his introduction of daring foreshortening, his cutting off of persons or objects by the frame, and his unusual angles have all overwhelmed many a writer by their novelty. These "innovations" have often been credited to Degas' familiarity with the camera, since he was, in fact, an ardent amateur photographer. But he became one only in his later years. Besides, in his day, photography was still in its infancy. The

camera, as yet a clumsy instrument, could not match the artist's ability to achieve the closeups and dramatic perspectives we admire in his work. Though Degas may have gotten some ideas from his hobby, it would be closer to the truth to suggest that it took the camera decades to lose its immobility and to catch up with his experimentations. If he was indebted to anything, it was to the Japanese prints that became popular in Paris after the 'fifties, and that employed asymmetry and bird's eye views as pictorial devices.

The Degas who continues to excite us to this very day is not the painter but the "Expressionist" draftsman, whether his tools are pencil, charcoal, or the pastel sticks with which he often achieves surprising painterly qualities. Looking at his output as a draftsman, one hesitates to categorize Degas as "the Last of the Great Old Masters." Instead, one discovers in him a modern, something of a precursor of abstract art. Subject matter increasingly lost importance for him. As the years sped by, his emphasis shifted entirely to movement, rhythms, and—in the late pastels—explosions of color.

DEGAS AND INGRES

In selecting eight personalities for his volume, *Great Draftsmen*, the Harvard historian, Jakob Rosenberg, correctly included Degas among the immortals: "We have chosen Degas as the outstanding figure of the nineteenth century, perhaps the only one who can follow Watteau without giving us a feeling of decline."

Oddly, Ingres was omitted from Rosenberg's volume, possibly because, with all his stupendous talents, he had a retrogressive quality. And, perhaps to his own dismay, he could not avoid having a retarding influence on the more docile of his pupils. Degas, as a matter of fact, started out as a pupil of a long forgotten *Ingriste*, Louis Lamotte, who spoke of his master in a tone of admiration as if there had been nobody else before or after him. Degas met the famous old man only once, yet to his end remembered the advice he received from Ingres, "Draw lines, young man, and still more lines, both from life and from memory, and you will become a good artist."

Luckily for Degas—and for the world of art—the neophyte did not wish to become a pale replica of Ingres. Only his very early pencil sketches—mainly portraits, copies of Old Master works, or preliminary studies for rather academic renderings of biblical or classical subjects—lack the spontaneous, the passionate element we treasure in the mature draftsman. Ingres would probably have disapproved of much, if not most, of what Degas was to produce after 1870, and would have deplored the "deformations" in the ballerinas, along with the ignobleness of the subject. He would have refused to look at Degas' bathers, laundresses, washerwomen.

In the baroque exuberance of his last pastels, Degas expressed himself in a decidedly *anti-Ingriste* manner and technique. For Ingres and his followers, color was the least important quality in a picture. As he grew older, Degas came closer and closer to the thinking of Ingres' antipode, Delacroix, for whom grayness constituted "the enemy of all painting."

WHY PASTEL?

I have said before that Degas devoted himself to pastels for non-artistic reasons. Indeed, the growing weakness of his eyes did not permit him to make and see extremely fine pencil lines, nor to mix pigments on the palette. But this medical fact is only a grain of the complete truth. As early as 1869, when he was thirty-five and still in top physical condition, he made some pastel landscapes as well as a pastel portrait of his sister, Thérèse. It is correct, though, that pastels as a "painting" medium assumed greater importance for him only in the late 1870's. From 1885 to the enforced end of his activity as a draftsman and "draftsman-painter" about two decades later, pastels were to be his prevailing medium.

There were many additional reasons for this preference. Pastels allowed him to work quickly, with those characteristic rapid movements that impressed his models. The medium required no drying time, and no varnishing. For a while, there was also a "commercial" factor. His dealer, Paul Durand-Ruel, found that he could sell these works easily, and Degas, at one point, badly needed ready cash.

DEGAS AND OTHER PASTELLISTS

The word "pastel" is derived from the paste into which pigments are compounded before being molded into sticks. These sticks are soft, fragile, and matte in appearance. Since pastel is essentially a dry substance directly applied to paper or, infrequently, to canvas, many writers tend to classify it among drawing media. Others speak of pastel *paintings* because their total effect can closely approach that of paintings in wet media. The chalky surface and texture of pastel, absent from an oil, cannot, of course, be concealed. In any event, both verbs—to draw and to paint—appear acceptable in relation to pastels. A master such as Degas can, indeed, manipulate pastels in either way.

It is a relatively new medium. Of its pioneers, the best-known was Rosalba Carriera (1675-1757), one of the few women to achieve fame in the visual arts prior to 1800. Early in life, this Venetian artist designed patterns for lace, and then painted miniatures on ivory. She finally discovered that pastels best conveyed the soft, caressing effects she wanted. Although Carriera's self-

portraits reveal her capacity to probe deeply into character, the bulk of her work, done first in her native country and then in France, was largely devoid of great artistic ambition. As Michael Levey has written: "She contented herself with a good likeness without commenting on the personality. That was not her business, and she made little effort to alter her formula, which was to draw a bust-length portrait against a plain background, with only slight variations between a set of stock-poses," (*Painting in XVIII Century Venice*).

She was no experimenter like Degas, whose mind never stood still, and who, as a portraitist, took pains to produce more than a flattering likeness. Unlike Carriera, and unlike the most celebrated eighteenth century pastellist, Maurice Quentin de La Tour (1704-88), Degas did very few "commercial" portraits, and, in any case, would make no concessions to please any sitter. By contrast, La Tour was strictly a businessman who did not hesitate to give his royal and aristocratic patrons all the elegance and charm they hoped for. In an age and society dominated by La Pompadour, and characterized by silks and satins, powderpuffs and scented fans, rouged lips and black beauty spots, La Tour congenially concentrated on his client's complexion rather than on his character. He made garments appear even more precious than they actually were, and altogether achieved what might be called an agreeable superficiality. Still, he was a master, the first pastellist with enough prestige to be admitted to the Academy. Despite his shallowness, La Tour's adroit craftsmanship thrilled so discriminating a collector as Degas. In fact, Degas was nearly heartbroken when, after the bankruptcy of his brothers' firm, he had to sell his small hoard of La Tour pastels.

Only one eighteenth century master, Jean-Baptiste-Simeon Chardin (1699-1779), betrayed some of the sophisticated realism that was to become the identifying mark of outstanding art in the era of Degas. This realism was apparent both in his pastels and in a good deal of his work in other media. Coincidentally, Chardin also took up pastels when old age and weak eyes demanded a medium less exacting than oils. One recalls his self-portrait in the Louvre, exceptionally and even ruthlessly realistic for the Rococo age in which he lived.

Among the admirers of this particular work was Paul Cézanne, who wrote to his disciple, Emile Bernard: "Do you remember that fine pastel of Chardin in spectacles with an eyeshade jutting out above them? This painter was cunning as a fox! Have you ever noticed how, by means of light, transversal lines across the nose, he brings his values into clearer focus?"

After the collapse of the Bourbon monarchy, the medium was unpopular for a while. The angry young men in the 1790's and early 1800's identified it with the frivolity and lasciviousness of the First Estate, to whom so many artists had pandered. But soon it was used again, with painterly effects, by Delacroix and particularly Millet. In the latter half of the century, it suited well such of Degas' closer associates as Renoir and Cassatt, and especially his friend Manet, who "painted" with it on canvas. These works, mostly delightful portraits of friends, were accomplished during the last years of his relatively short life, when illness did not permit Manet to stand on his feet, as easel painting required. The American painter Whistler used pastels, mainly during his sojourn in Venice. There are pastels in the *oeuvre* of Toulouse-Lautrec and Vuillard, and even in that of a young Montmartrois from Spain, Picasso. But apart from Degas, the only major pastellist in pre-World War I Europe was Redon, maker of Surrealist flower pieces of the most subtle delicacy.

EXPERIMENTS IN PASTEL

None of these artists greatly improved the technique of pastel "painting," though they all vastly expanded the area of subject matter. The only experimenter of significance was Degas. True, he produced many pastels done in a manner not much different from La Tour's. But Degas went far, far beyond La Tour. To begin with, he carefully selected paper which was often tinted and of differing degrees of roughness. Degas would also combine pastel with water or watercolor and work it with a brush; or add gouache, distemper, or oil thinned with turpentine. Often he used monotypes for a base over which pastel was applied. Monotypes are made by applying slow-drying pigments (ink, oil, or oil diluted with turpentine) to non-absorbent surfaces (glass or copper); the image is then transferred by laying paper on the plate and applying pressure by rubbing or passing through an etching press. He took one or two impressions, and on the resulting picture worked with the pastel sticks.

Not satisfied with the relatively low intensity of color achieved through conventional methods, he went out of his way to increase the luminosity of his pastels. Often he invented methods no one had thought of before and which no one would bother to use after him. Many of his techniques are doomed to failure if tried by anyone less stubborn, less fanatical, and less skilled than Degas. These technical methods have intrigued scholars. Douglas Cooper writes that, having created many pastels with uniformly applied strokes and smooth surface, after 1880 Degas began "to produce a broken surface texture, to emphasize contrasts of light and shade, and to create atmosphere and a sense of depth by juxtaposing strokes of contrasting or related tones running in several directions."

A thorough study of the artist's techniques was undertaken by Denis Rouart, a relative of Degas' friend Henri Rouart who also participated in Impressionist shows. In *Degas à La Recherche de sa Technique*, Denis Rouart has taken such trouble to explain the master's complicated procedures that full quotes are preferable to any attempts to rewrite his scholarly explanations.

According to Rouart, one of Degas' highly original procedures consisted of "laying in his subject in pastel and then spraying boiling water over it. This made the dry pastel into a paste. He worked into this paste with brushes of varying stiffness. If the water was sprayed onto a thin layer of pastel, the result was more like a wash which could be spread with the brush. He took care not to spray the water vapor all over his picture, so as to keep the original surface of the pastel where he wanted it to give variety. He would not treat the flesh of a dancer in exactly the same way as her *tutu*, or the scenery might be given a different quality from the floor."

Between 1892 and 1895 Degas added further subtleties to his method. To quote Rouart again: "No longer content with getting his effects only by the direct opposition of tones and colors, he attempted to make the areas of color vibrate by using small superimposed touches of opposing colors. By this means he tried to approach the magnificent color of the Venetians as far as possible."

Contrary to common practice, Degas fixed his pastels heavily. That is, he applied frequent layers of fixative, a thin liquid which serves as an almost invisible varnish or adhesive which bonds the chalk to the painting surface. "He sketched in his picture with strong, rich color, and then fixed this layer very thoroughly," says Rouart. "Then he worked again over the colored surface, without fearing that his new touches would disturb the existing color. Leaving the ground to show through here and there, he made the new colors play against the existing ones, reinforcing some and neutralizing others. This operation of fixing and reworking would be repeated several times until the work was finished—that is to say, to the point at which he felt satisfied.

"In the following years, he perfected this method, in which he continued to use very broad hatching strokes. This application of pastel in successive layers, each being fixed, is certainly Degas' own invention. He adapted to pastel the technique of making colors play against each other by superimposition and transparency rather than merely by the opposition of color areas. Transparency could not, of course, be obtained in pastel as it could be with glazes in oil paint; so he arrived at an analogous effect by working in successive layers, not covering the lower layer entirely but letting it show through.

"The greatest difficulty with this method was to avoid disturbing the color over which he worked. This demanded a fixative of a very high quality. After trying a number of recipes, Degas was helped in the search for a satisfactory fixative by Luigi Chialiva. Apart from this, the method was entirely by his own development." This fixative vanished with the death of its inventor.

REPETITION OF SUBJECT

All this innovative work was done most quietly, without any fanfare at all. Besides, however much time he spent experimenting with techniques, Degas was entirely satisfied to paint a few, very limited subjects. He might take a train, but it would not occur to him to fasten his attention on the locomotives pouring forth their blue steam, and to make a series of paintings of the railroad station, as did Monet at the Gare Sainte-Lazare. He traveled more than any other artist of his generation, and was the only European painter of note to visit the New World before 1900. But the many months he spent in New Orleans yielded only one major picture dealing with the local scene, the celebrated one showing the interior of a cotton buyer's office. In Italy, he copied Old Masters or made portraits of friends, but one looks in vain for equivalents of Monet's rendering of old palazzi.

As a matter of fact, after he turned away from producing anecdotal pictures that still had something of the *peintre pompier* (the conventional *Salon* artist of the Second Empire), he limited himself to so few subjects that all could be represented in the thirty-two plates selected for the present book. But this self-limitation was a product of discretion rather than narrow-mindedness. "I want to see nothing but my corner and dig away obediently," he once declared. "Art doesn't grow wider, it recapitulates." Despite Degas' small repertory, Edmund de Goncourt noted in his diary after a visit to the artist's studio: "He is the man I have seen up to now who has best seized, in reproducing modern life, the soul of this life."

What the novelist seems to have meant was that the work he saw in the cluttered studio expressed the new times, as did, for instance, the novels of the Naturalist School to which Goncourt and the younger, and more famous, Emile Zola belonged: a spirit of ruthless dedication to truth, unencumbered by hypocrisy or false sentimentality. The bourgeois, who still rejected Degas for his "vulgarity," liked to go to the official *Salon* to view pretty, narrative paintings. But this was exactly what Degas did not give.

The German master Max Liebermann wrote about Degas, whose pictures he collected: "No modern artist has so completely subdued the anecdote." André Malraux more recently made this acute observation: "The prime characteristic of modern art is that it does not tell a story" (*The Museum Without Walls*). Degas' works tell no tales. If they make a "social impact," they do so against the in-

tentions of the artist who, in all likelihood, did not care about the wretched lot of the washerwoman wearily pressing her heavy iron on the ironing board; nor had he compassion for the tired *modiste,* trimming hats for carefree rich ladies. He and the socialist-minded artist Gustave Courbet could never have become friends!

THE DANCERS: AN EXCUSE TO DRAW

He wasted just as little pity on what appears to be his most favored subject, the young dancers of the opera ballet corps—the little *rats,* as they were called, or those "small female monkeys," as Goncourt described them with equal lack of sympathy. Degas had his regular place in the orchestra stalls and, as a season ticket holder, the privilege to wander about backstage. Sometimes he would sketch under the partial concealment of his large black cloak, but more often he just memorized their gestures as the *rats* practiced or wearily rested, their muscles taut or tired. "He observes without painting, and paints without observation," John Rewald felicitously noted. Significantly, Degas was not interested in the celebrated, well paid ballerinas, but only in the little plebeians of the *corps de ballet.* Their work was hard; their salaries were scant. Many of them, we are told, engaged in prostitution either for financial gains or to advance to a leading role in the limelight through the intercession of a man of importance.

If Degas lacked compassion, did he, perhaps, derive a morbid delight from watching these unfortunates, whose ill-nourished bodies were deformed by the demanding, excessive muscular effort? There was nothing sadistic about him, though he was repeatedly accused of being "cruel." He simply spent no emotion on these *élèves,* protesting that he was only interested in the pretty materials and the movement: "The dance is for me only an excuse to draw." His cold, sharp eye caught, and his hand summarized, the weariness and frailty of the young body in a few decisive strokes. He watched these unsmiling girls as they adjusted their slippers, stretched their muscles, went through their steps. One feels that they were often bored to death, that they hated to be controlled in every pose and gesture.

One senses, rather than actually sees this in the faces, which, if visible, remain only the most rudimentary sketches. Degas, if he cared to, could draw the human face better than anyone else of his period. He had the ability to pierce the mask and to probe deeply into the character. Yet as a rule, he gave us more or less interchangeable, depersonalized creatures, their "faces" overshadowed by the expressive dynamism of arms and legs. He wished to render movement and, especially in the gaily colored skirts and bodices of his later pastels, to create miracles of color.

THE NUDES: EXTREME REALISM AND UNSTUDIED POSE

Except for the most preliminary sketches done on the premises of the *Opéra,* the work was carried out in the studio, where hired models would repeat for him, over and over, the poses he had seen under the roof of the theater. In the same *atelier,* he would also command the model to undress casually and leisurely, to take a bath, to dry herself, to comb her hair, in order for him to obtain what today would be called a candid camera shot. This extreme realism earned him the praise of Guy de Maupassant, who wrote into a copy of one of his own books, "To Edgar Degas, who paints life as I would have liked to be able to paint."

British critics, especially, were enraged by his methods, and by his choice of subject matter. One, mistakenly believing that Degas was a pupil of Ingres, deplored that a disciple of the painter of *La Source* should create "such appalling creatures."

By the same token, his motives were misunderstood again, particularly in England, when he said that he wanted to portray his nudes as though he had watched them through a keyhole. To a Victorian, such a statement could have only a lascivious meaning. Actually, his drawings and pastels of nudes—in poses Ingres would have considered unworthy of representation—were not meant as insults to womanhood, the revenges of a diehard misogynist. Degas' wish was for the unpremeditated, unstudied pose. He got what he wanted by inviting underprivileged women to indulge in ablutions of all sorts. His models welcomed them at a time when a bathtub of any sort was both a luxury and a rarity in many quarters of Paris.

To his painterly eyes, breasts were no more fascinating than a towel or a chair. "I show them deprived of their airs and affectations, reduced to the level of animals cleaning themselves," he said of his models, without intending this as an insult. He was no Boucher, willing to paint a well coiffured, pretty nude lying prone on a fine bed. His model's hair is often disheveled, her face frequently hidden, or her back even completely turned to us. As she bends over, her buttocks, exaggeratedly large, appear closest to the beholder. Undoubtedly, many observers, used to the "graceful" pose of the "classic" beauty presented in the *Salon de Bouguereau,* found these pictures horrid. The public was looking for prettiness rather than character and, least of all, for art. When asked by an irate lady why he always made women appear so ugly, he gave the unfortunate answer, "Because women *are* ugly!" Yet he was no Schopenhauer, no Strindberg, as can be gathered from scores of pictures in which physical beauty is not denied to the sitters.

Henri Matisse, challenged by someone's comment that she had never seen a woman who looked like that, gave a more fitting retort, "But, Madame, this is a picture, this is not a woman!"

DEGAS AND AMERICAN PATRONAGE

During Degas' lifetime, Americans were not often willing to make the necessary sharp distinction between a picture as an independent entity, and the person or thing represented; they were likely to confuse the two. Hence, before and even beyond World War I, there was little enthusiasm here for the works of the Impressionists, whose creations appeared to be too sketchy, too raw, too "unfinished." Degas, though the least Impressionistic of them, was not exempted from these criticisms. Americans wanted hyper-imitations of nature. *Nouveau-riche* collectors after the Civil War found even Degas too free for their taste, and confined themselves to Old Masters and their modern emulators.

During Chicago's Columbian Exposition of 1893, where works by Degas were included in the exhibition "Foreign Masterpieces Owned by Americans," a critic wrote that they were "of little value except as specimens of the Impressionistic school." He expressed surprise that Degas, "a man who seldom completes a picture," was hailed by his brethren as one of the most talented and original artists of his day (*The Proud Possessors* by Aline Saarinen).

Luckily, he had a propagandist in the person of Miss Cassatt, his disciple and admirer, who advised her friends and family back home to buy his work. She was particularly successful in influencing her brother Alexander, president of the Pennsylvania Railway, as well as the Potter Palmers and Mrs. Henry Havemeyer. Before becoming the millionaire Havemeyer's wife, wealthy young Luisine Waldron Elder bought, on the advice of Mary Cassatt, a Degas pastel of a ballet rehearsal. She was to recall later: "I scarce knew how to appreciate it, or whether I liked it or not, for it takes special brain cells to understand Degas."

Thus, we owe thanks to Miss Cassatt and to others (among them the painter William Glackens, adviser to Dr. Albert C. Barnes of Merion, Pennsylvania) who early understood the importance of Degas. Because of them, the United States is now extremely rich in works by this master, and they can be found in more than thirty public collections.

DEGAS AND THE CONTEMPORARY EYE

These collections embrace examples of all the media in which Degas worked. But today's art appreciators—especially those born after Degas' death in 1917—have shifted the focus of their admiration away from the comparatively traditional oils and toward the master's work in other media: his more illusionistic, less precise prints (especially the monotypes), his experimental sculptures, and above all, his pastels. The contemporary eye is particularly compelled by the large, late pastels in which impersonal figures, devoid of individuality, provided Degas with spontaneous movements in all their curves. In these works, Degas indulged in color explosions unequalled by anyone of his own generation, with the exception of the half-blind octogenarian Monet. Jean Sutherland Boggs has written that these late pastels ". . . often seem the most moving to twentieth century eyes because they express the anxieties which have troubled our century most."

Along with the late pastels, our volume also presents earlier, less "Expressionist" works. These pastel drawings, or paintings, have merits of their own which the fickleness of human taste must not be permitted to belittle, let alone bury. For they, too, can be a source of delight to anyone willing to walk with unprejudiced eyes through art's many mansions.

Indeed, it appears at this point that the epitome of all that Degas was and stood for can be found in his pastels. This was the opinion of so astute an observer as Oscar Wilde. In 1894, he informed the editor of a British newspaper that he had been unable to obtain a personal statement from the reticent Degas. But he comforted his correspondent: "Why say anything about his person? His pastels are himself."

Color Plates

1. SIX FRIENDS OF THE ARTIST

1885. 45¼" x 28". (113 x 70 cm.)
Museum of Art, Rhode Island School of Design,
Providence, Rhode Island.

All the artists who were dubbed "Impressionists" by the French critics painted portraits and self-portraits now and then, but none was as active and prolific a portraitist as Degas. When, as a young artist, he tired of painting likenesses of the large De Gas clan, his father encouraged him to approach this genre more cheerfully, since, as De Gas put it, his son's portraits would prove to be the most beautiful jewel in his crown. Indeed, Degas' portraits and self-portraits are remarkable for their technique as well as for their psychological penetration. Jean Sutherland Boggs has written that, all his grumblings notwithstanding, more than one fifth of his *oeuvre* must be classified as portraiture.

This group portrait, most unusual in its composition, was a by-product of a sojourn at Dieppe (a seaport in northern France that attracts numerous summer visitors). One of the six, and the only one whose name may still ring a bell, was the English painter, Walter Richard Sickert (1860-1940), who has written about its genesis:

"My second meeting with Degas was at Dieppe in the summer of 1885, when we learned with delight that he was staying with the Ludovic Halévys, next door to Dr. Blanche's chalet on the seafront by the Casino. It was in Jacques Blanche's studio in the Châlet du Bas Fort-Blanc that Degas drew the pastel group . . . one figure growing onto the next in a series of ellipses, and serving, in its turn, as a *point de repère* [direction] for each further accretion. In the order of age the figures were: Monsieur Cavé, who had been Minister of the Fine Arts under Louis Philippe . . . Ludovic Halévy, Gervex, Jacques Blanche, and I and Daniel Halévy. This drawing Degas presented with a profound bow to Madame Blanche when it was finished. Ludovic Halévy pointed out to Degas that the collar of my overcoat was half turned up, and was proceeding to turn it

down. Degas called out: 'Laissez. C'est bien.' Helévy shrugged his shoulders and said, 'Degas cherche toujours l'accident'."

When this was published, in 1907, many readers of *The Burlington Magazine* may have been familiar with the six *dramatis personae*. Today, some additional explanations are required. The bearded man in the upper right, the artist's host Ludovic Halévy, was a novelist and playwright, as well as Henri Meilhac's collaborator on the libretti of George Bizet's *Carmen* and of Jacques Offenbach's operettas. Below him, in the straw hat, is his thirteen-year-old son Daniel, who later gained fame as an historian and biographer, but is best known to us for his memoirs, *Degas Parle . . .*, published here as *My Friend Degas* (1964). At the bottom is Albert Cavé. At the right, between the Halévys and Cavé, are the French painters Henri Gervex (with stiff hat and pointed beard) and, above him, hatless, Jacques-Emile Blanche, son of Dr. Blanche. To the right, isolated, is "the young and handsome Sickert," as Degas referred to this colleague in his letters.

This composition defies tradition. A more conventional artist would have composed a tightly knit group, rather than the seemingly disconnected parade of figures Degas chose to paint. Oddly, these individuals seem to be quite unaware of each other. Did Degas wish to express a cynical view of human nature—that people, oblivious of each other, are only interested in their own thoughts and feelings? Incidentally, the asymmetry and overlapping often occur in Degas' work.

This is the largest of all the pastels reproduced here. The size of sheets usually available for purchase at art supply stores was roughly 19" x 24". Whenever Degas wanted to make a larger picture, as he often did, especially in the final years of his career, he added strips of paper, or joined together several sheets.

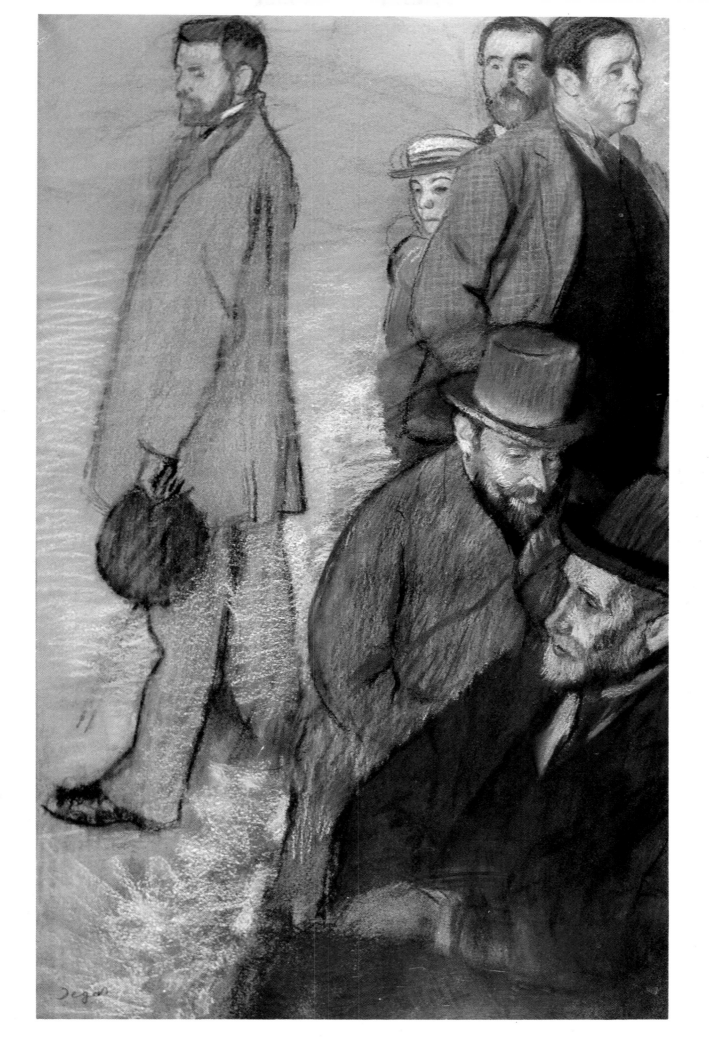

2. MADAME DIETZ-MONIN

1879. 23⅝″ x 17¾″. (59 x 44 cm.)
National Gallery of Art, Washington, D.C.
Gift of Mrs. Albert J. Beveridge.

All we know about the sitter and her relationship with the artist is contained in this unsigned, undated letter by Degas:

"Dear Madame,

Let us leave the portrait alone, I beg of you. I was so surprised by your letter suggesting that I reduce it to a boa and a hat that I shall not answer you. I thought that Auguste or Mr. Groult to whom I had already spoken about your last idea and my own disinclination to follow it, would have informed you about the latter.

Must I tell you that I regret having started something in my own manner only to find myself transforming it completely into yours? That would not be too polite and yet

But, dear Madame, I cannot go into this more fully without showing you only too clearly that I am very much hurt.

Outside of my unfortunate art please accept all my regards."

The reference to the hat and boa was prompted by the lady's offer to send her hat and boa instead of arriving in person for her sitting. Naturally, Degas was offended.

The editor of Degas' letters, Marcel Guérin, informs us that the oil painting, which obviously pleased neither the sitter nor the artist (who felt that he had already yielded too much to the lady's idiosyncrasies), was presumably destroyed by Degas. It seems that against his custom Degas had accepted a portrait commission—and soon was to regret it. For he was no Manet or Renoir, who might at times try to accommodate a patron, nor one of the fashionable portrait painters of the century, who were generally innocent of aesthetic and moral scruples. Undoubtedly, the lady

expected to be flattered! Yet, to judge by the pastel, and by the more colorful pastel and tempera sketch now in the Art Institute of Chicago, Degas could not have done anything but present her as the plain, uninteresting, middle-aged bourgeois woman she was.

The first man mentioned in the letter is Auguste de Clermont, a friend of Degas and the lady's son-in-law; the second, M. Groult, a famous collector of eighteenth century art. About the portrait painter's dilemma, André Malraux reports an observation, made in his presence by a great artist (who is unfortunately not identified), to Modigliani: "You can paint a still life as you wish, and the collector will be delighted; a landscape, and he will still be delighted; a nude, and he may begin to look worried; his wife—well, that depends But when you set to work to paint his own portrait, if you dare to tamper with his sacred mug, then, my friend, you will see him jump" (*The Museum Without Walls*).

Degas' very approach to portraiture was bound to annoy, or at least mystify, all but the most advanced of his contemporaries. His mature portraiture, and much of his other work, is characterized by a technique which might be called selective focus. As the term implies, the artist decides which parts of a face or form to finish, and which to leave unfinished. Whereas Ingres rendered each bit with painstaking accuracy, a good deal in this pastel by Degas is blurred. While it is probable that the oil painting (for which this was a preliminary sketch) was more finished, it is unlikely that, to please his patron, the artist relinquished his method of emphasizing what he thought was important by making it sharp, and de-emphasizing the less important elements by drawing or painting them slightly out of focus.

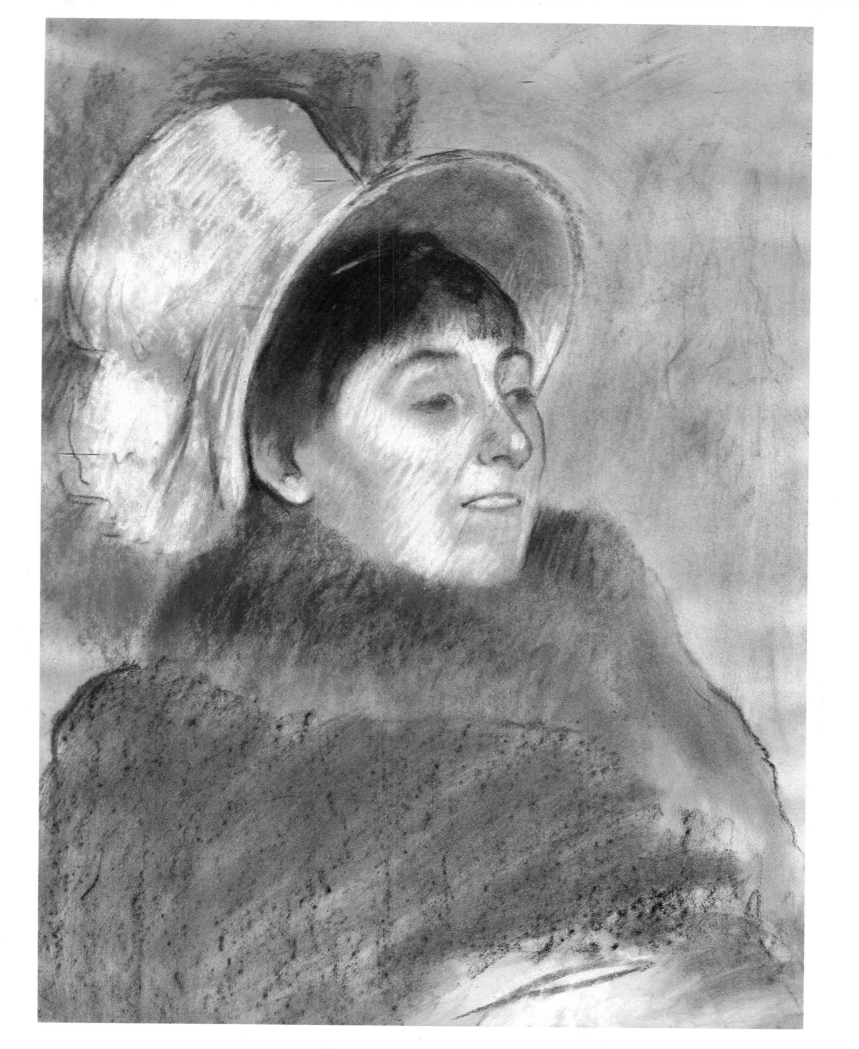

3. SKETCH FOR "PAGANS AND DEGAS' FATHER"

1882. 18⅞″ x 24¼″. (47 x 61 cm.)
Philadelphia Museum of Art, Philadelphia, Pennsylvania.
Mr. and Mrs. Carroll S. Tyson Collection.
Photo by A. J. Wyatt.

Lorenzo Pagans was a well known Spanish tenor who made his debut at the Paris *Opéra* in 1860. No fashionable *soirée* in Paris was complete without Pagans. A familiar figure at Edouard Manet's musical evenings, he was acclaimed by the famous novelist Edmond de Goncourt as "our musician." In 1869 Degas painted a canvas (now in the Louvre) which shows the singer accompanying himself on the guitar. Pierre-Auguste-Hyacinthe De Gas is in the background. Another, less conventional oil on the same theme is in the Museum of Fine Arts, Boston.

Much later, Degas produced a third, and rather different, double portrait. In this oil, currently in a private collection in Michigan, Pagans, older and grayer, no longer plays an instrument, but reads a book. Auguste De Gas, a pale, ghostly figure, is seen seated in the background, though he had been dead for eight years when this work was painted.

The pastel reproduced here is a preliminary study for this double portrait. It contains the musician's figure, but only a hint of the table, which appeared in the oil. There is no indication of the chair included in the final version. And, in place of De Gas, there is just a smudge and swirl of lines to indicate where the figure will be placed.

Though dated by scholars as late as 1882, this pastel is still more subdued in color, more "academic" than other work of the same period in this medium.

4. REHEARSAL ON THE STAGE

Ca. 1873. 21″ x 28½″. (53 x 61 cm.)
The Metropolitan Museum of Art, New York, New York.
The H. O. Havemeyer Collection. Bequest of Mrs. H. O. Havemeyer.

It is instructive to compare this picture to the well known oil, *Mlle. Fiocre in the Ballet "La Source"* (The Brooklyn Museum, 1866-67), one of Degas' earliest excursions into the fantasy world of ballet. In the oil, the three performers and the horse do not move; everything is quiet. There is no trace of the excitement, the dynamic unrest that characterize his later ventures. Here in the pastel, however, there is lively movement, and the fascinated eye is drawn from one figure to another.

The theater in which the action takes place was probably the Salle de la rue Pélétier, which was destroyed by fire in the fall of 1873. The bald, stocky ballet master—placed somewhat off center and conceived as a vivid, if slightly comic figure—has not been identified with certainty.

The picture is so convincingly realistic that one might believe it was drawn right on the spot. Actually, Degas used his amazingly retentive memory to reconstruct the architecture of the scene in the solitude of his studio. He then called in his model, making her repeat, over and over, the many poses he required. "When you work for Degas," one model complained, "you can feel every bone in your body." Though the picture looks as if taken from life, the artist arranged the figures arbitrarily to achieve a perfect design. He earned praise from his older colleague, Puvis de Chavannes: "No one else has so well found the exact place for each figure in his pictures, so that it is impossible to move them without spoiling the whole."

For the sake of special effects, Degas put velvet sashes and bows on the little dancers, although he very well knew that the dancers did not have them. For he always adhered to his principle, "Even in front of nature one must compose."

The girls themselves, while individualized, are woven together into an ensemble (note Degas' characteristic use of the empty space). They all betray different attitudes. Slightly off center, one is busily pirouetting. The one nearest to the professor is yawning, from boredom or fatigue. One is scratching her back. A highly ironic note is introduced by the two elderly men in the background, who, casually seated, do not pretend that their interest is loftily aesthetic, but observe the scene with the delight of *voyeurs*.

Note the magic of the artificial light, and the interesting foreshortenings. The pale gauze skirts contrast with the director's dark suit, as well as with the top of the bass viol. The Metropolitan Museum of Art, incidentally, also owns and displays the slightly different version, in oil. A monochrome oil version is in the Camondo Collection of the Louvre.

The pastel is the most developed and, probably, the most satisfactory of the three pictures. Apparently, the genesis of all three was a pen drawing that Degas submitted to the *Illustrated London News*: "The editor refused it because the ballet was not considered suitable subject matter for a prudish Victorian reading public" (*French Paintings: A Catalogue of the Collection of the Metropolitan Museum of Art, vol. III*).

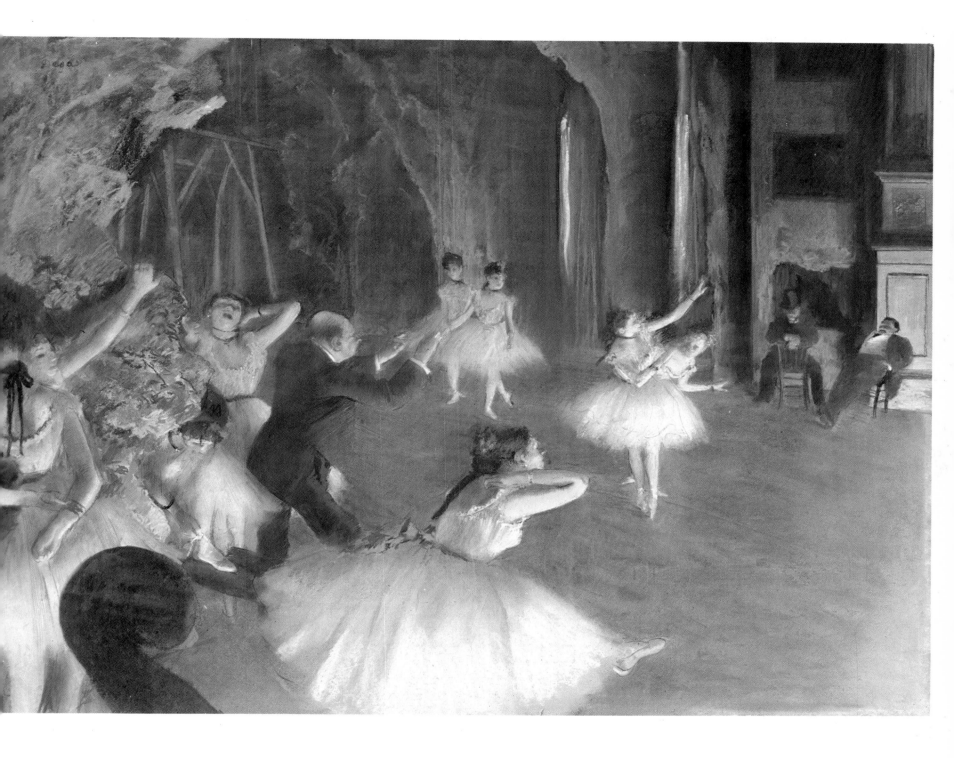

The artist sought out the dramatic in his presentations. He often chose an unusual angle and manipulated an exciting juxtaposition of unexpected forms, quite different from his fellow Impressionists who, on the whole, were satisfied with the ordinary views revealed to the unsophisticated traveler. However, Degas influenced Toulouse-Lautrec, who learned to transform a scene with the sharp penetration of intellect, rather than to submit meekly to the boredom of reality.

Here interest is heightened by the presence of the elegant and elaborately jeweled spectator, whose head and large black fan cut off part of the view. This unconventional compositional technique is similar to the pastel on Plate 4, in which the top of the large instrument protrudes its form into the world of the stage.

The theme of this pastel is a frequent one in Degas' work. The victorious ballerina, an aerial creature (notwithstanding her plain visage), is curtseying to the noisy, insistent beat of the music. Transfigured in the glow of lights, she is graceful in her décolletage, her bosom scarcely concealed by the white bodice. Having achieved her triumph, she appears with a bouquet of flowers, still wrapped in paper, sent by an admirer—perhaps one of the wealthy, yet not entirely unselfish patrons of the arts.

Degas did not share the Impressionists' passion for outdoor light. The majority of his works (the race-track pictures are the most notable exceptions) are interior scenes, illuminated by artificial light. He also differed from the Salon painters and *Beaux-Arts* professors, who invariably placed the light source in their pictures above and off center. This classical approach to lighting created a traditional pattern of light, halftone, and shadow, upon which the artist relied to create volume and dimension, and to model form.

Degas, however, reversed this tradition and often placed his light source *below* his figures, very much like theatrical footlights—and with the same dramatic effects. His light and shadow patterns are just the reverse of what one would expect. Observe, for example, that the lower part of the dancer's face and the bottom of her arm are in full light, while her forehead and the top of her arm are in shadow. In this revolutionary manner Degas at once created weird theatrical effects and revealed form in an unprecedented way.

An interesting entry in his notebooks reads as follows: "Work a great deal with the effects of evening, lamp, candles, etc. It [this method] is provocative, rather than to show invariably the source of the light to indicate the effects of light. This aspect of art can become immense today"

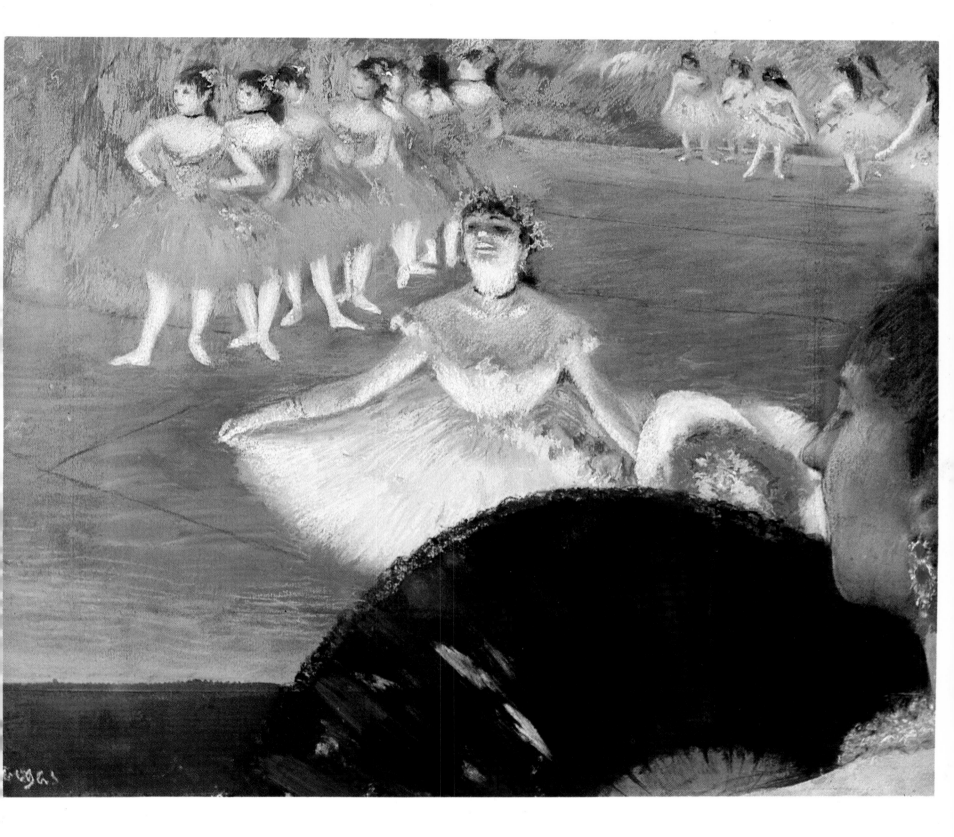

6. DANCER AT THE BAR

Ca. 1880. 26¼″ x 18½″. (66 x 46 cm.)
Shelburne Museum, Shelburne, Vermont.

We are told that serious ballet students arrive in the classroom some time before the lesson, to begin stretching at the *barre*. The little dancers must spend countless hours practicing before their muscles are completely flexible and able to execute the strenuous figures required by the ballet.

This adolescent, looking down at her left foot, seems to be a beginner, ill at ease in her effort at *pointe tendue* (leg extension, with pointed toe). In this picture, unlike others on the subject of the ballet, there are no great chromatic contrasts. The colors are soft, subdued, undramatic. Variety is brought in only by the bit of red in the girl's hair, the brownish-red base board, and the yellow bar on which she rests her arm.

Lillian Browse commented that Degas had "a special feeling of tenderness for the *rats*" and that his pictures often "show compassion for these pathetic young children obediently drilling their thin little bodies to take up what must be admitted to be the most unnatural of positions." However, others think—with more justification—that he was indifferent to the private tragedies of these dancers (as he was to those of the washerwomen at their ironing boards). His attitude, according to this interpretation, was that of an upper class historian recording with harsh fidelity the lives and actions of his social inferiors. Be that as it may, Degas repeatedly watched these proletarian girls rehearsing in the bare, cold rooms of the ballet school. In all likelihood, their economic background was of no more concern to him than it was to the audience, interested only in the spectacle.

Incidentally, this is one of the relatively few pastels of dancers showing the subject's face. Degas' figures rarely look directly at the spectator (this is also true of his portraits). But even here, only one eye is drawn; the remainder of the face is a blur of shadow. One might say that in his works it is the body that speaks; the face, if seen at all, is de-emphasized. All his figures are absorbed in their activity: isolated, they pay no attention to whatever else may be going on in the same room.

Although this is not an early picture, the pastel strokes on the arms and legs follow the form around. A few years later the strokes are to become increasingly at war with the form—they will go against it, fight it, and take on a life of their own.

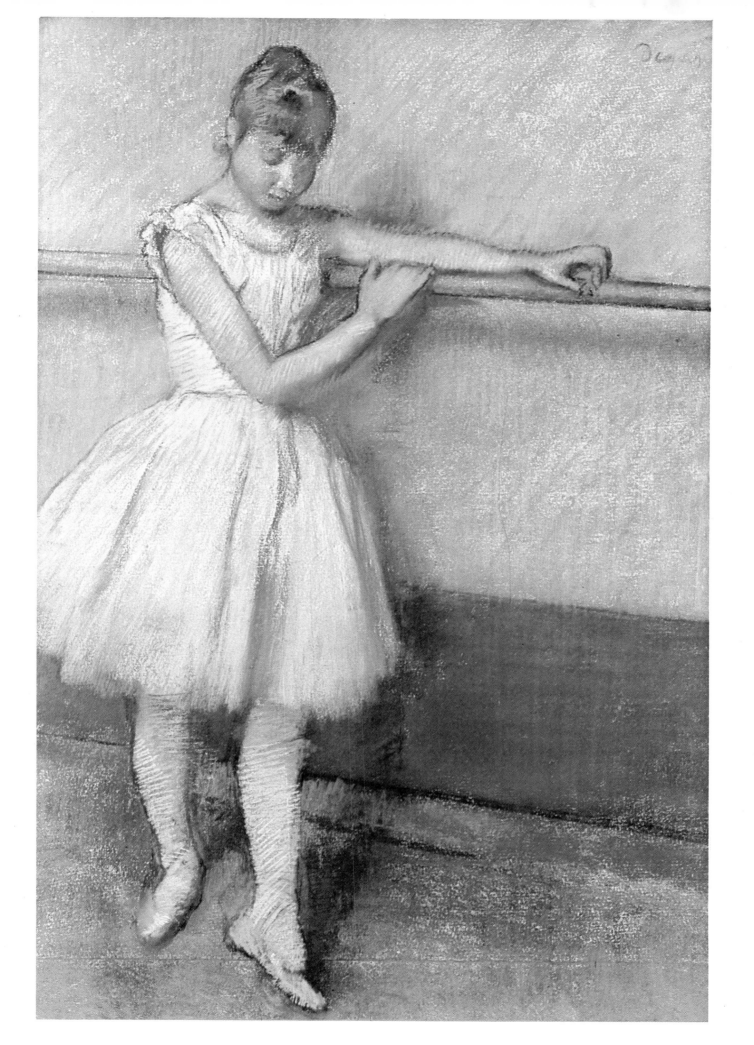

7. DANCERS AT REST

Ca. 1880-92. 19¾" x 23". (50 x 58 cm.)
Museum of Fine Arts, Boston, Massachusetts.
Juliana Cheney Edwards Collection.

In the last century the subject of dancers attracted many an artist, but only Degas so often showed dancers, and in positions devoid of charm, far away from the "glamour of the footlights." There is no glorification of the *prima donna*. Degas' emphasis is on the un-heroic aspects, on the prosaic side of the life, on frustration, pettiness, and even ugliness. Often the artist portrays the dancers worn out from endless practicing at the *barre*. They sit with their skirts spread around them, their weary legs outstretched. They yawn or scratch their backs. In all cases, they look exhausted.

The interest of this composition is largely due to the diagonally placed red bench; the girls are seated on two levels and at right angles. Except for some student sketches, Degas never used the artificial studio poses that were customary. He preferred to catch his subjects off guard, especially in moments of relaxation. If others saw the little dancer as a pretty butterfly, soaring and flutter-ing before being swept into the river of music, Degas frequently interpreted her as an unhappy creature with bruised wings.

The averted faces of the dancers are characteristic of Degas. However, the most striking aspect of this picture is the extra-ordinary use of negative space. The dancers and the bench, though ostensibly the "subjects," occupy only a small part of the picture area. Most of the painting is empty—shockingly so for its era. No Academician of Paris would have dared provoke criticism by creating such an unorthodox composition, or to have sliced the picture in two with the flat diagonal, as Degas has done here.

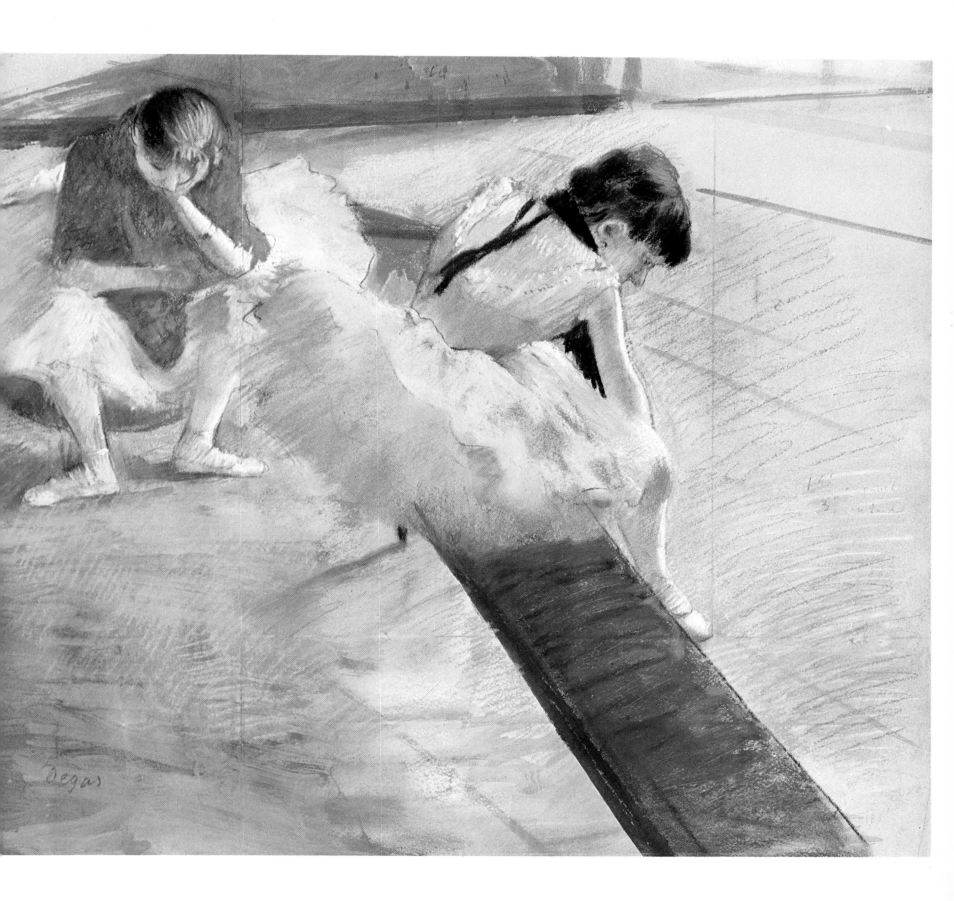

8. BEFORE THE EXAM [THE DANCING CLASS]

Ca. 1881. 24¾″ x 18½″. (62 x 46 cm.)
The Denver Art Museum, Denver, Colorado.

This picture is related to another celebrated pastel, *The Mante Family* (ca. 1889, private collection, New York), in which the mother ties a bow on her daughter in dancing costume, while another daughter, in street clothes, stands by. Here, the class is about to begin. The dancer at the extreme right is practicing *battement tendu à la seconde*, an exercise in which the working leg is opened to the front, side, or back, with the toe resting lightly on the ground, and then closed again in fifth position. The one standing behind her bends forward to pull up her tights; while she does so her mother fluffs out her skirt. The elderly lady, seen full face, resembles Degas' devoted housekeeper, Sabine Neyt. Note the contrast between the filmy gauzy costumes of the girls and the dark, drab street clothes of their mothers, aged beyond their years.

The slanting floor, with its cracks, and the diagonals of the wall define the space. In their "pictures of a floating world," the Japanese printmakers used the same compositional trick to create the illusion of deep space. The clustering of figures in one corner is also a Japanese device. Kitagawa Utamaro (1753-1806), in particular, liked to place the subject at one side, leaving the other side more or less empty. Degas saw such Japanese prints long before 1867, when many were shown at the *Exposition Universelle*, which made *Japonaiserie* the great fashion. He owned Japanese color prints, and one of his friends, Edmond de Goncourt, wrote the first major study of Utamaro.

Degas' composition flagrantly violates the dictates of academic composition. Notice his bold practice of making one figure partly block off and conceal another, and even of chopping off a figure by the frame. By these means, we are drawn towards the periphery of our field of vision. The dancer at the right actually appears to be leaving the picture.

While all these innovations may have shocked the *derrière-garde* eighty or ninety years ago, we feel today that the picture's impact is increased by this "candid camera" technique, and that the unity is not impaired by the non-axial, asymmetrical composition.

About this picture, J.-K. Huysmans wrote: "How true, how alive it is! The figures seem to exist in air. Light bathes the scene convincingly. The expressions on the faces, the boredom from their painfully mechanical work, the scrutinizing look of the mother whose hopes will harden when the body of her daughter wears away, and the indifference of their companions to drudgery they know, these are emphasized and recorded with the pointedness of an analyst who is always both cruel and subtle."

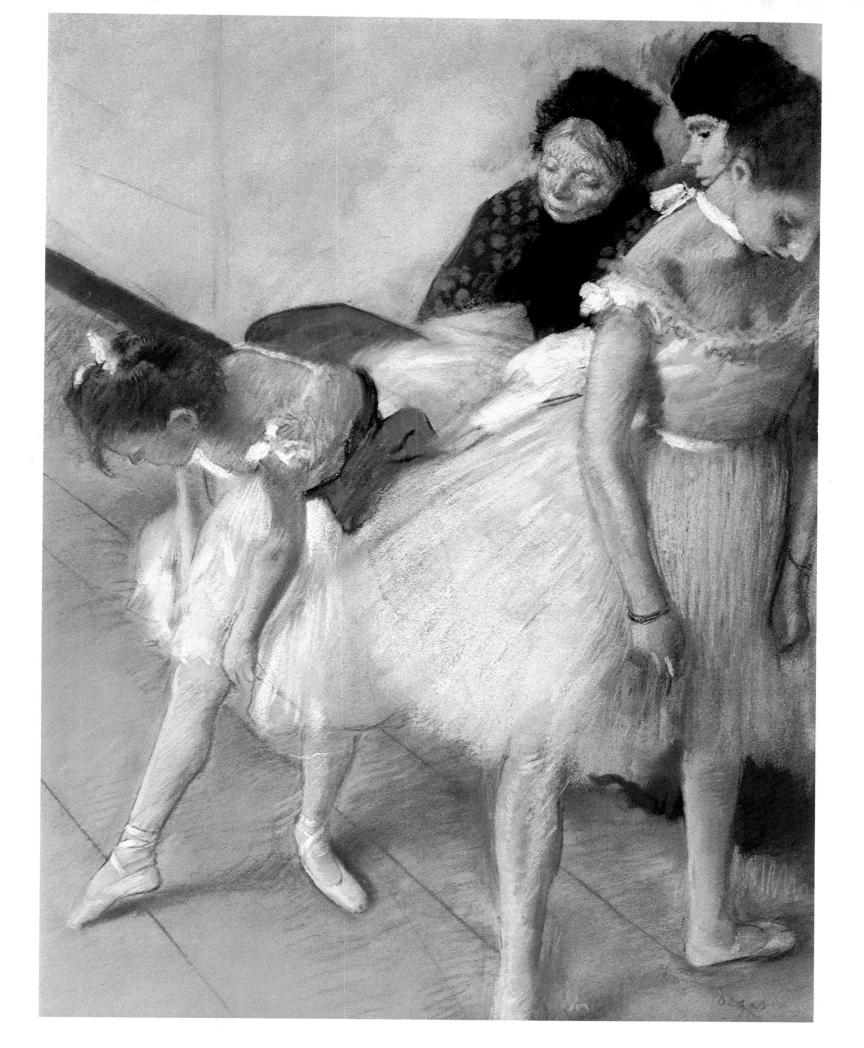

9. DANCER IN HER DRESSING ROOM

Ca. 1879. 34⅝" x 14⅞". (77 x 37 cm.)
Cincinnati Art Museum, Cincinnati, Ohio.

It has often been argued that Degas hated females and did not want them to seem pretty. But what about this charming little creature in her dressing room! Indeed, few of his pictures are so devoid of harshness. He complained that he was called the painter of dancers: "No one seems to understand that the girls are just a pretext for painting pretty material and studying movement." On the other hand, in an unguarded moment he confessed to a colleague that although he was growing old, his heart had remained young, and "the ballet dancers have stitched it up in a pink satin bag, dusty-rose colored satin like their dancing shoes." But this remark is so atypical of the Degas we claim to know that we cannot attach too much significance to it.

Note the way the artist manipulates color by placing bits of red cloth on the floor. Note, too, the experimental angle of view, not rare in the work of the Japanese printmakers, but in sharp contrast to the classical principle of painting on eye level with the subject. By *Ecole des Beaux-Arts* standards, this picture has many faults: it is painted from above eye level—an unorthodox angle which is magnified by the artist's use of diagonals and verticals. By placing the figure high up in the picture, so that there is more foreground than background, an exaggerated recession is created. Finally, the format is exceptionally narrow. Yet through these very "sins," Degas makes dramatic what in the hands of a lesser man would be a rather humdrum, "cute" subject.

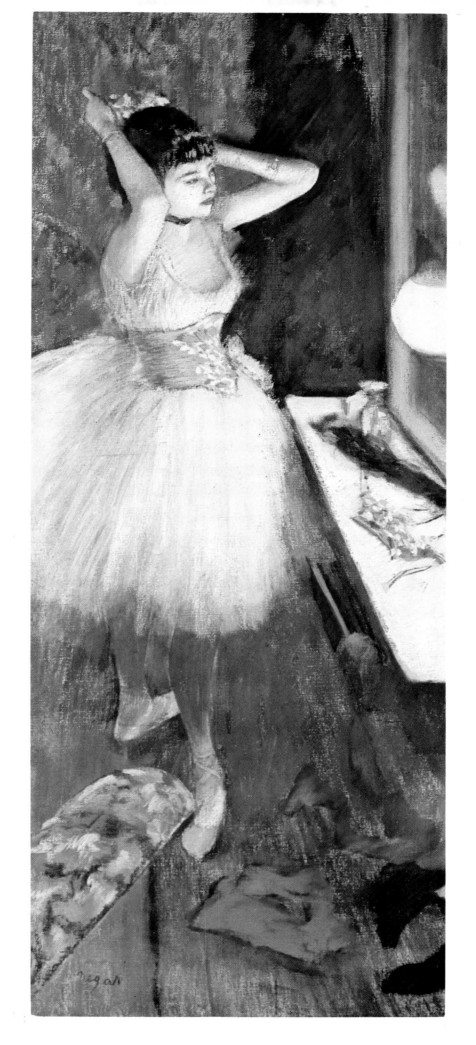

10. PINK DANCERS

Ca. 1900. 33″ x 22¾″. (83 x 57 cm.)
Museum of Fine Arts, Boston, Massachusetts.
Seth K. Sweetzer Residuary Fund.

Degas' repertory of poses is small. There are several pictures like this, in which dancers appear beside a bit of stage setting in a moment of frozen action, their arms lifted in a graceful gesture, their backs turned to the audience.

By 1900, Degas no longer cared for close, analytical scrutiny of movement. All that mattered to him were fluid and blurred forms, displaying deep, rich textures of color. Subject is still visible, but it is no longer of primary importance. Degas is opening the door here for the pure painting that developed into a major force in the early decades of the new century. Ten years later, but still during Degas' lifetime, Kandinsky created the first non-objective, non-figurative pictures.

Indeed, the elimination of detail in this pastel (there are neither eyes nor nostrils in the patches of color that stand for faces) is a tremendous step in the direction of aesthetic goals formulated by Wassily Kandinsky, the Blue Rider Group, and the Futurists, after Degas had virtually terminated all work and all interest in the world of art.

Though Degas began as a linearist, in his mature work lines appear infrequently—only, for instance, to keep a leg from melting into the background. The strokes move their own way instead of revolving around the body. Note the interlocking network of cool strokes of color over warm, of pink and blue, orange and green.

The crumbly, thick texture is the very opposite of the smooth, thin surface in the work of the eighteenth century masters. Degas' progression from the linear to the painterly has reached its climax with the neglect of contours and three-dimensional modeling. One particular compositional audacity must be stressed: the vertical dark from the foreground tree chops off one-third of the picture, while the figures cut off each other.

Degas may have witnessed a scene similar to this picture in one of the ballets at the opera. But by 1900 he had long stopped attending performances there, and this haze of color vibrations does not have any close affinity to whatever he may have observed from his seat in the theatre. To him, the image in the mind was now more fruitful than the one that could be captured by the retina. He explained to a friend:

"It is all very well to copy what you see, but how much better to draw only what the memory sees. Then you get a transformation, in which imagination works hand in hand with memory, and you reproduce only what has particularly struck you—in other words, essentials. In this way your memories and your fancy are freed from nature's tyranny. This is why pictures so made, by a man who has cultivated his memory, is familiar with the masters and knows his business, are nearly always outstanding works. Look at Delacroix."

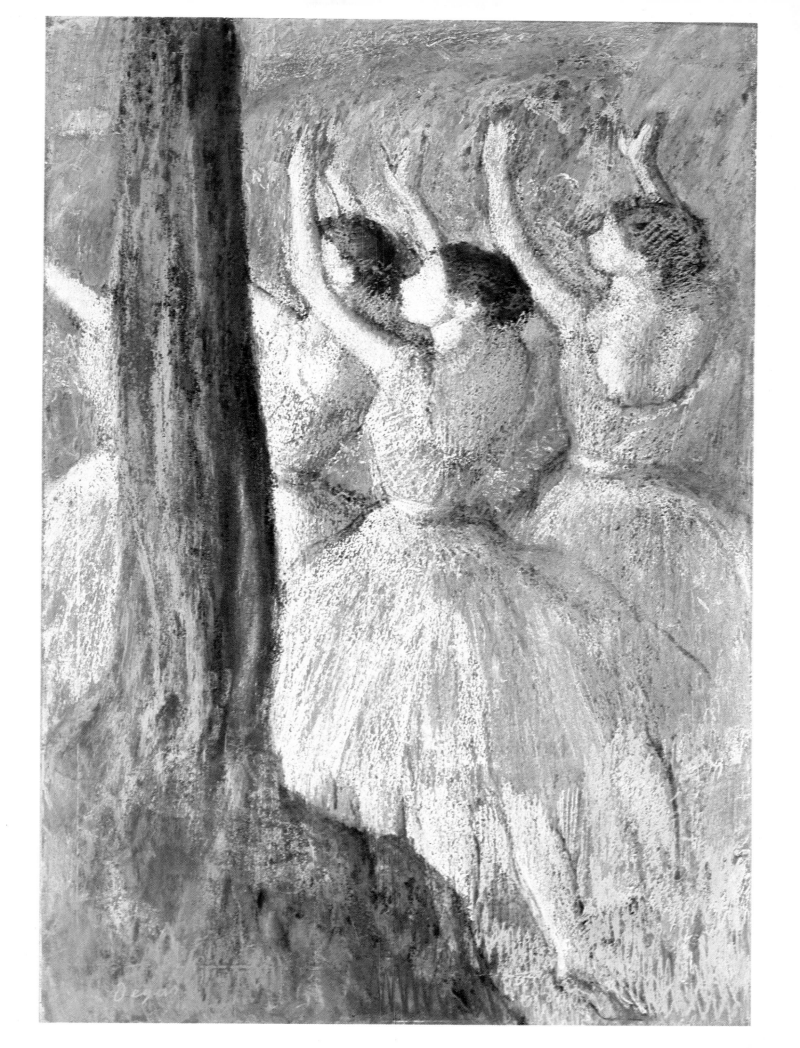

11. DANCERS

After 1900. 22⅓″ x 18¼″. (56 x 46 cm.)
The Art Museum, Princeton University, Princeton, New Jersey.

It is a trivial topic. The central figure is seen scratching her back. But her action is as unimportant as the girl herself. What matters is the mass, the planes of rich color barely contained by the blurred contours, the expression of vitality without any sharpness of definition. This work anticipates the day when painters will ignore subject matter altogether, or rather make pure color their subject. But it took Degas about four decades to arrive at this shimmering evanescence of light. His early palette, one recalls, consisted largely of Manet-blacks and Chardin-whites, of browns and greens, blues and grays.

Now Degas goes so far as to "invent" color, arbitrarily. The green and red shadows, for example, have no equivalents that can be observed in nature. On the rough paper, the strokes cease to be strokes and become jumbles of color. One is inclined to think of Action Painting (which did not flourish until about three decades after Degas' death). Here, forms dissolve into big, rough, raw patches of color. Layers of warm and cool colors alternate one over another. The skin tones, for example, are built up from parallel strokes of cool green and warm orange, vertically applied. This juxtaposition, which calls upon the viewer's eye to mix and blend, creates exciting visual vibrations.

Degas also made clever use of unexpected lighting: the figure is plunged into shadow. Sudden, unexpected, and arbitrary lighting is used to emphasize or play down the forms. In this work, Degas' unorthodox practice of cutting off one figure by another creates unexpected spatial relationships. The dancers crisscross and intersect, with disconnected parts of their bodies appearing and disappearing in surprising ways. These broken figures begin to function for Degas as independent design elements.

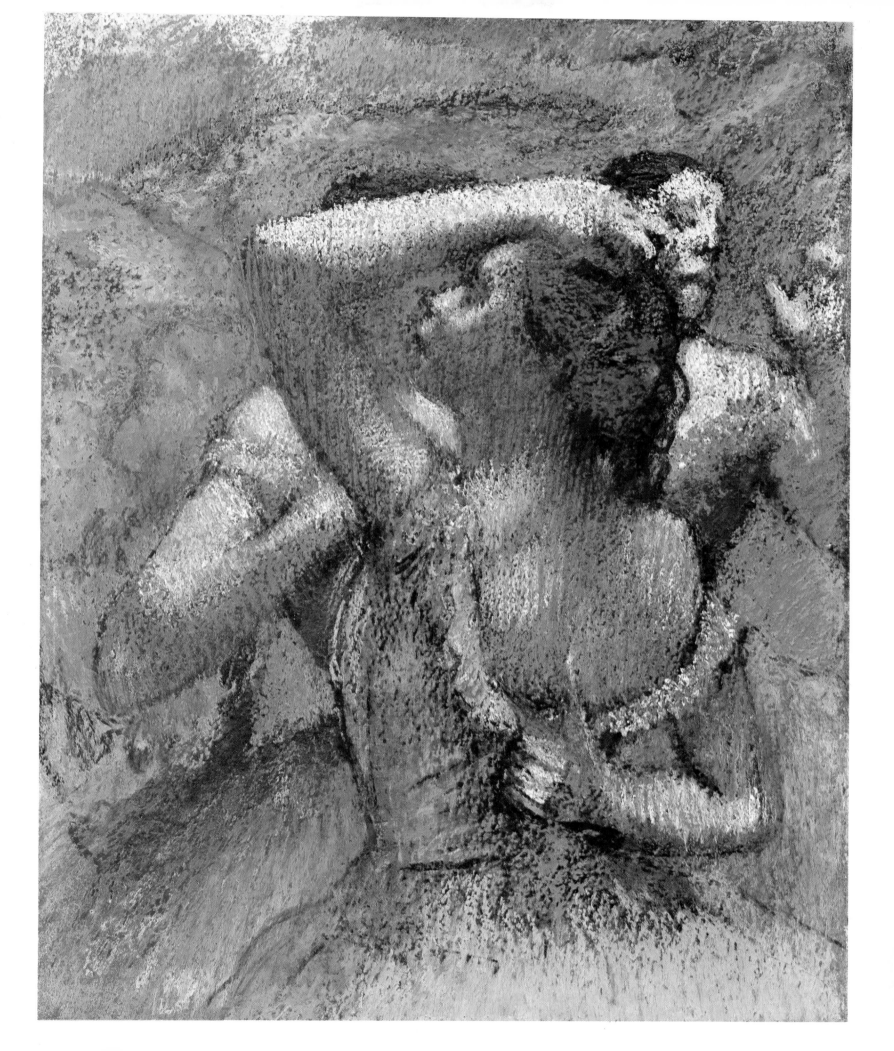

12. THE DANCERS

1899. 24½" x 25½". (61 x 64 cm.)
The Toledo Museum of Art, Toledo, Ohio.
Gift of Edward Drummond Libbey.

The three dancers appear to be ready to go on stage. In the very last minute, two are adjusting their costumes. Although, unquestionably, a model posed in the studio for all three figures, Degas creates the impression that the scene was seized and fixed instantaneously. Yet it is less photographic than earlier works on the ballet theme. No longer interested in rendering solid form, the aging artist concentrates on composition (note the interesting angles defined by the arms) and on atmosphere, created by shimmering, iridescent color, more brilliant than anything Degas accomplished in the medium of oil.

In his *Memoirs*, the painter William Rothenstein (1872-1945) remarked on Degas' late pastels, produced when the artist's vision was already so poor that he could only distinguish part of an object at a time:

"Young people today, who prefer the later works of Degas and Renoir, hardly realize how much of its looser character was due to their failing eye-sight.... Towards the end of his life he [Degas] was obliged to use the broadest materials, working on a large scale, hesitating, awkward, scarcely able to find his way over the canvas or paper."

Rothenstein did not take into consideration the fact that an artist, aware of his physical handicap, tries to overcompensate, to turn necessity into virtue. What the late drawings lack in accuracy, they make up for in forcefulness and intensity. One may recall that Beethoven created some of his most glorious compositions after deafness had struck.

In his own way, Degas was as bold an innovator as Beethoven. Note that only the arms and faces of these dancers have any modeling, while everything else is just a rich play of color. Indeed, the dancers themselves serve only as an excuse for making free use of color. Hardly any lines are noticeable. The red-orange shadows on the skin are completely arbitrary.

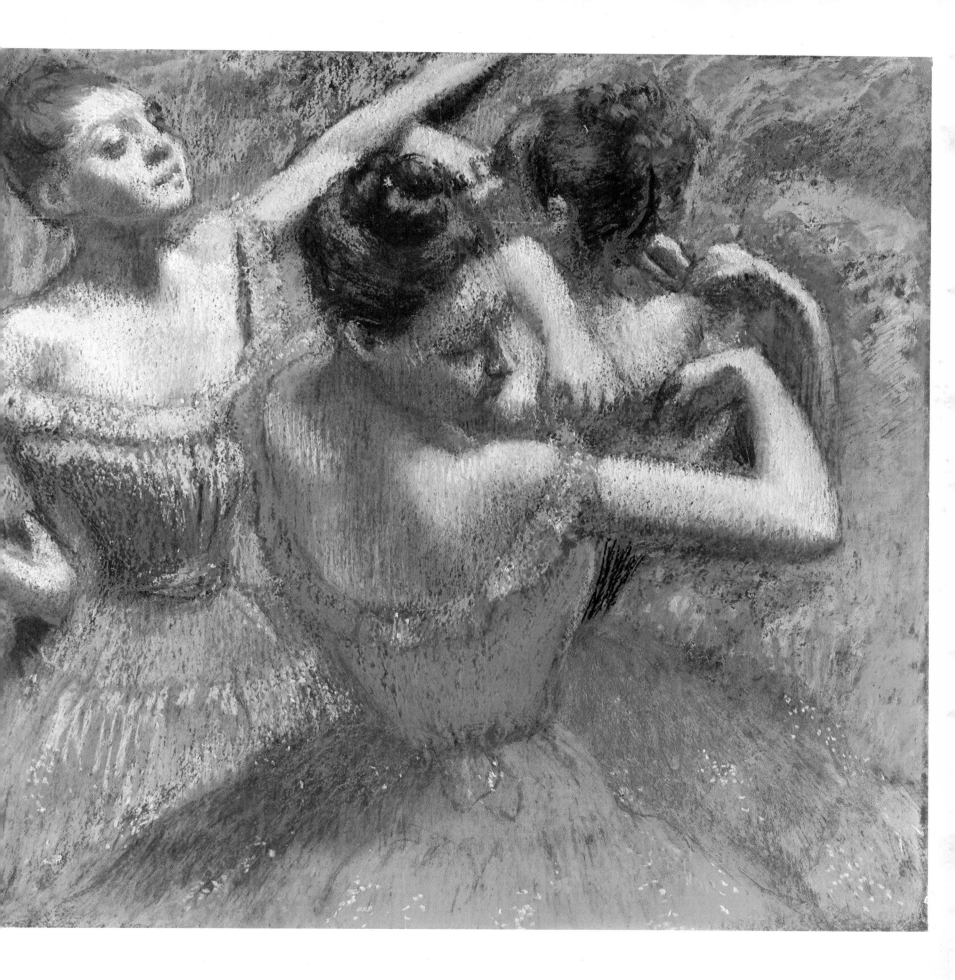

13. THREE DANCERS PREPARING FOR CLASS

Ca. 1886. 21½″ x 20½″. (54 x 51 cm.)
The Metropolitan Museum of Art, New York, New York.
The H. O. Havemeyer Collection. Bequest of Mrs. H. O. Havemeyer.

The closely integrated figures and striking use of diagonals (floor and windows) make this an intriguing composition. The triangle of dancers pulls the entire composition in the direction of the upper right hand corner.

In his mature pastels, Degas applied his color roughly and boldly, building up broad masses and minimizing detail. In this painting, the composition hinges on broad, relatively flat, roughly textured masses of dark and light. The colors here are weird; the figures seem to dissolve into hot shadows and big patches of warm color. While more conventional artists generally minimized cast shadows, Degas exploited them, integrating them into the allover design, as he has done in the shadows cast on the floor in this painting.

As usual, the dancers are anonymous; facial features are omitted, except for the corner of a nose or an ear. Degas was always fascinated by back lighting—which often came from a window at the rear of the interior. It is this light which dramatizes the back of the central figure, the edges of arms, heads, and costumes. This back light also gives Degas the opportunity to throw cast shadows into the foreground, toward the viewer, once again giving the feeling of diagonally receding space.

Throughout his mature work, Degas was fascinated by the interplay of warm and cool color, particularly in shadow areas where contrasting strokes are interlaced, warm showing through cool, to produce a fascinating optical vibration. Here, this interplay is particularly evident in the wall behind the dancers and in the floor of the foreground.

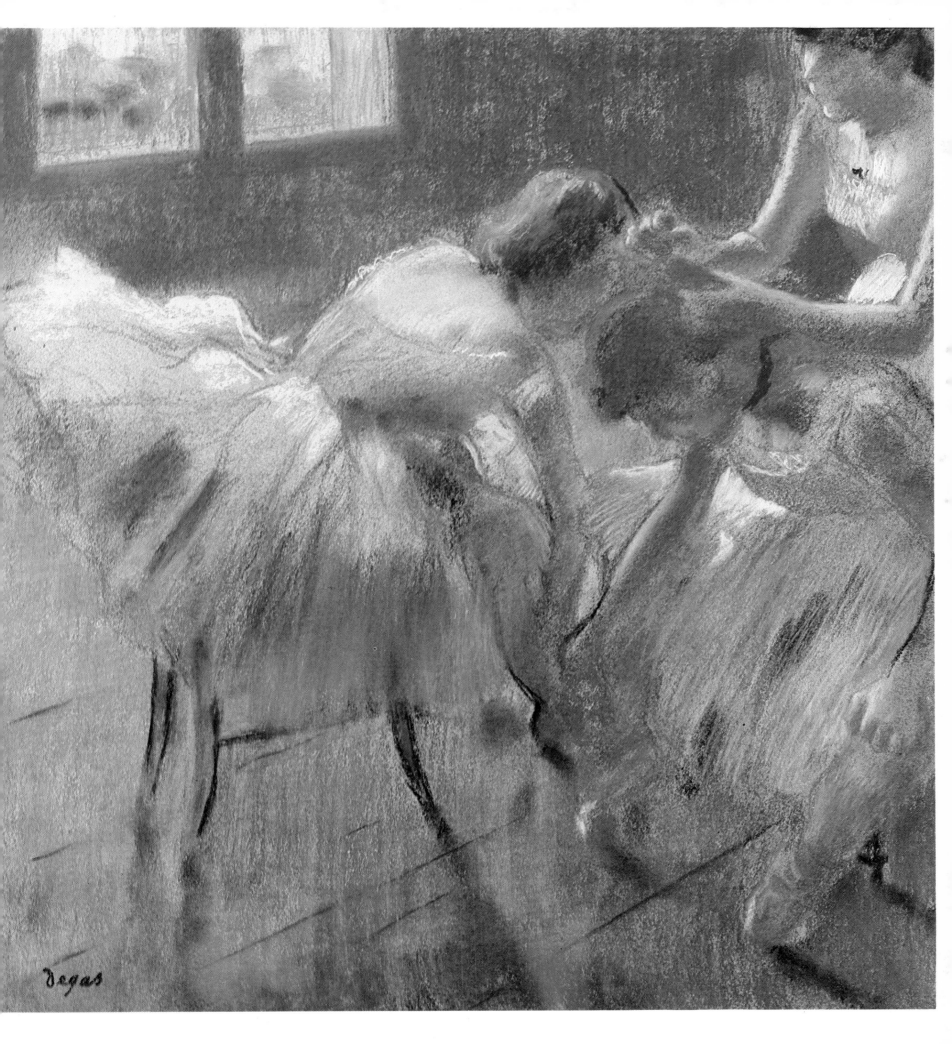

14. TWO DANCERS

After 1900. 23¼″ x 18¼″. (58 x 46 cm.)
Museum of Fine Arts, Boston, Massachusetts.
Given by Mrs. Robert B. Osgood in memory of Horace D. Chapin.

These two figures are almost identical with the two *danseuses* on the left in *Ballet Dancers in the Wings* (Plate 15). Degas very frequently dealt with one theme, either repeating the composition *in toto*, or concentrating on one or more figures. He made countless preparatory sketches, and would do the same motif in several media. A perfectionist, he sought with fanatical zeal to improve his work. For Degas there was no formula, only the absolutely right form. To find this form, the artist made numerous variations on the same theme. Not all were necessarily meant for the eyes of the public.

It goes without saying that he would not have permitted many a sketch to be exhibited or reproduced. If one may assume that by signing a work Degas gave his approval to it, then the present pastel is in this category. Yet there are also excellent pieces among the countless unsigned works, especially the very late ones, that carry only the stamp of the posthumous Degas sales of 1918 and 1919 to identify them.

To facilitate the making of several versions, he often used monotypes and counter prints as bases for other, almost identical works. The process of the monotype is explained on page 15. The counter print is made by transferring drawings (including pastels) by pressure from one sheet of paper to another. The resulting reversed image on the second sheet is comparatively faint. These duplications, however, enabled Degas to make whatever improvements or refinements he deemed necessary.

As if to defend the frequency of works which show only slight variations, he once made this statement: "One must re-do a thing ten times, a hundred times, the same subject. Nothing in art must resemble an accident, not even movement."

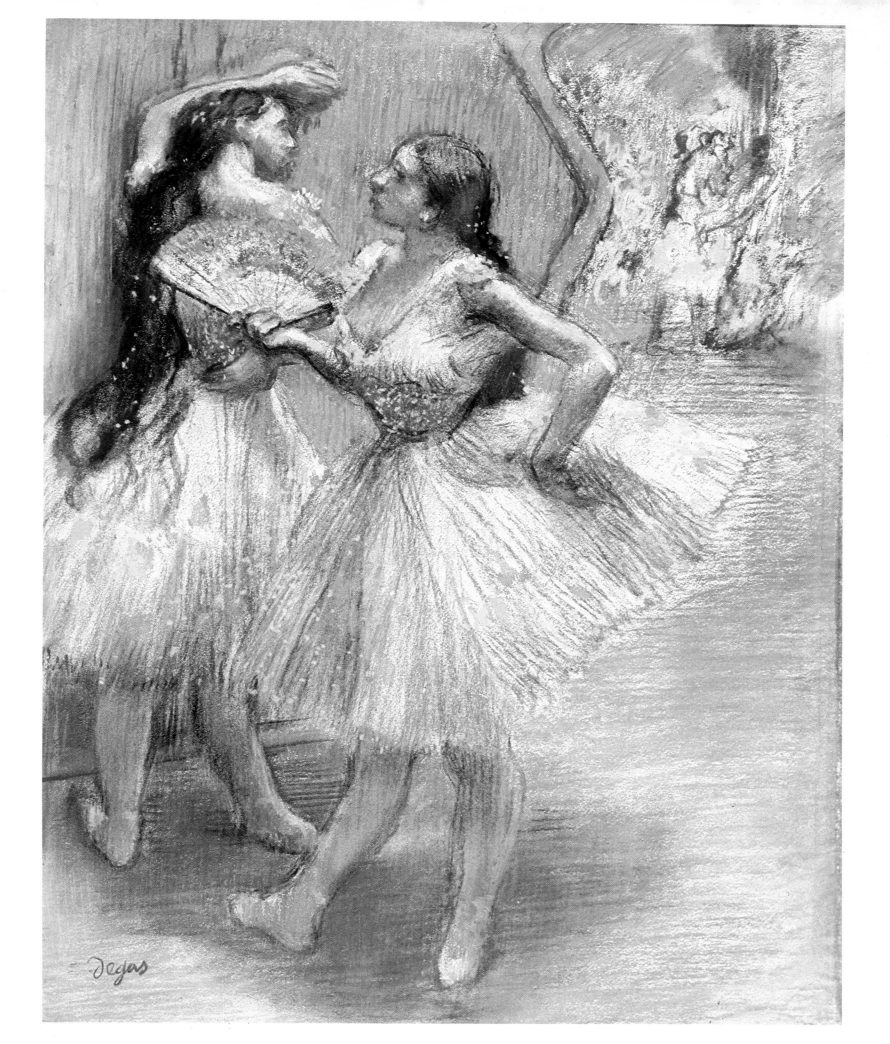

15. BALLET DANCERS IN THE WINGS

1900. 28″ x 26″. (70 x 65 cm.)
City Art Museum of St. Louis, St. Louis, Missouri.

There is nothing naturalistic about Degas' final pastels. They seem to be points of departure for flights of chromatic imagination. By 1900, Degas had long stopped going to the theatre. Yet he kept recalling what he had seen before. In this instance, he remembered the desperate weariness of the dancers, who lean against a stage set or fan themselves, still drenched from their exertions. While the purely human element is not absent from this work, its true subject is color. Degas has spun a dream in rare blues, with rhythmically distributed spots of pink, yellow, and brown.

Soon after its acquisition, the City Art Museum, in its *Bulletin* of January 1936, devoted an article to the picture, emphasizing the purely aesthetic aspects:

"The intense colors have been chosen and massed in quite arbitrary fashion to accentuate the decorative effect. The vivid pink and red which symbolize the flesh tones are boldly outlined with free strokes of dark brick red against the shimmering blue and green of the ballet costumes. These bright hues follow out and emphasize the dominant lines of the composition in a decorative way unrestricted by the limitations which a more natural rendition of lighting would have imposed. One feels that the intensity of the flesh tones, the titian-colored hair, the bright lemon highlights, transcends nature to accomplish a higher orchestration of color."

Most unorthodox is Degas' attempt to split the picture right down the middle, into halves, in contradiction to the time-hallowed idea of a picture's "unity," an unbreakable commandment for classical painters and their followers. Centrifugally, each pair of dancers leans out in opposite directions. Note the unusual dominance of cool blue, green, and yellow.

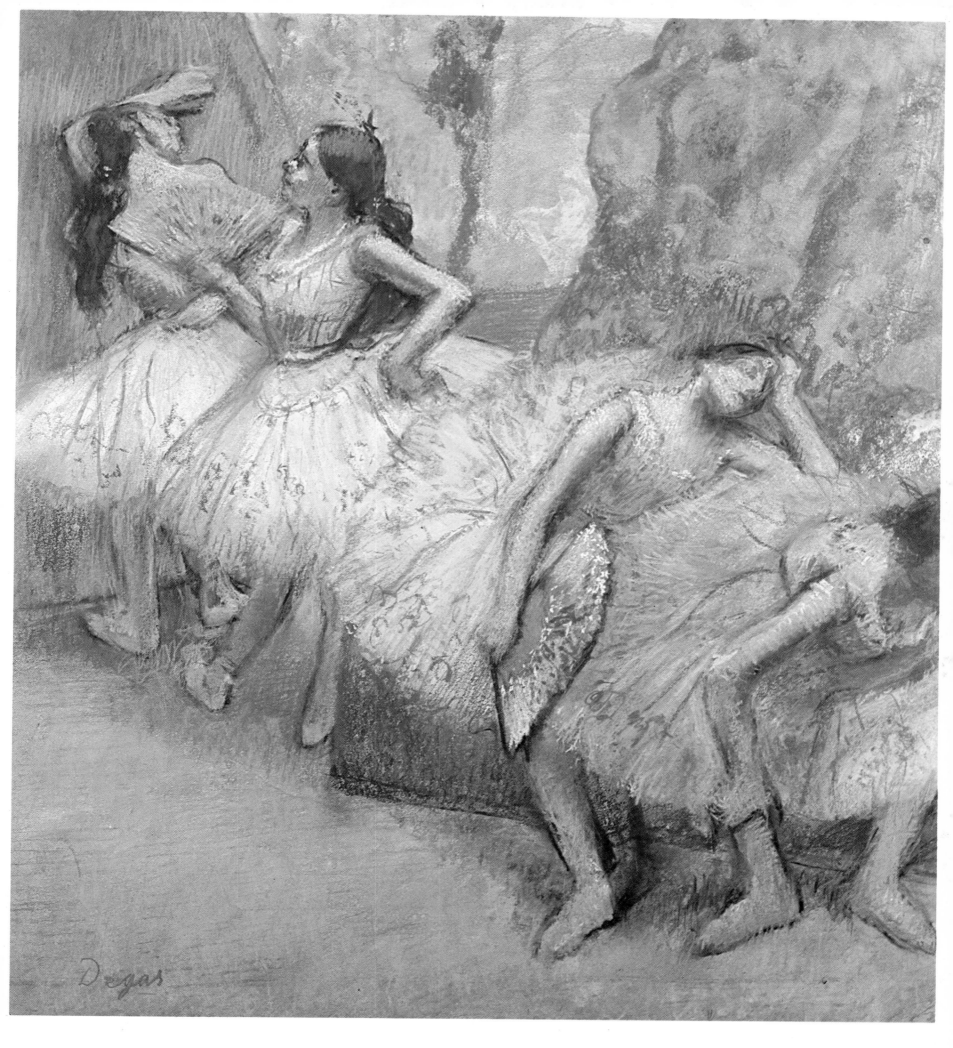

16. THE DANCERS

After 1900. 37" x 27½". (93 x 69 cm.)
The Memorial Gallery of the University of Rochester,
Rochester, New York.

It is a long road from the rather naturalistic, carefully modeled, and well defined dancers Degas painted in the early 'seventies to these ghostly specters. The three dancers coalesce into a tightly knit group, peering from the stage wings like surrealist carriers of luminous color rather than creatures of flesh and blood. And how far the artist has progressed from the brownish sauce of his early pictures to these high-keyed chromatics!

In the museum's *Bulletin* of 1931, soon after the acquisition of this stunning picture, the director, Gertrude Hertle, correctly pointed out that Degas never achieved with oil pigments the "brilliant iridescence of light-pervaded color" that one observes here.

"Two passages in particular in *The Dancers* are cited in this claim to his greater power with the pastel—the admirably foreshortened back of the dancer on the right and the face and neck in shadow of the middle figure, where he has broken his solid shadow tones with a skillful hatched technique, giving not only their proper forms to surfaces which presented difficult problems of drawing but also serving as a brilliant color area in the general design."

How far the artist has moved away, in the course of two decades, from the "prettiness" of the pastel in the Cincinnati Art Museum (Plate 9)! The scribbly strokes make no attempt to model, or even to follow the form. There are green shadows on the back, and the arms look like snakes. All of the artist's wildest innovations seem to come together in this picture.

50

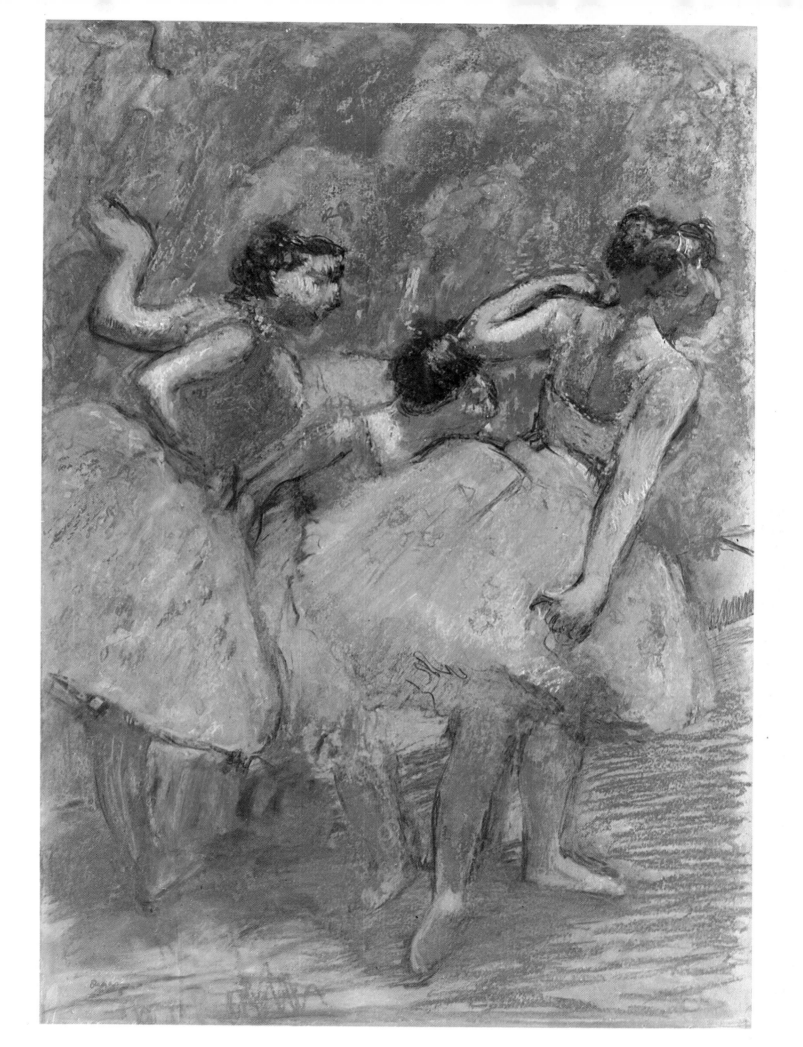

17. BALLET SCENE

Ca. 1907. 30¼″ x 43¾″. (76 x 109 cm.)
National Gallery of Art, Washington, D.C.
Chester Dale Collection.

Here, the predominantly pink, mauve, and blue bodices and *tutus* (diaphanous skirts) are sharply set off by the acid green tropical background. This work displays a sort of Bengalic illumination; the figures are ghosts. The picture, clearly Post-Impressionist, anticipates several twentieth century trends. Its interesting patterns and arbitrary colors are far removed from the fidelity to nature that had been the credo of the Impressionists, last heirs to the Renaissance tradition. Long before this picture was done, Degas pointed out that while the Impressionists needed natural life, he required artificial life!

Note the large format: Degas could no longer see well and needed to enlarge everything. Yet even in his old age, he retained his marvelous sense of perfect design, so much admired by Gauguin (who did not easily bestow praise upon a colleague). And while Degas did not think of himself as a colorist, the opaque richness of color in his last works is unsurpassed. Daniel Catton Rich has written about his final dancers: "Their faces are slashed with coruscating color; they look like strange, fierce birds or tropical butterflies."

There are no faces, no anatomical details of any kind. The colors of the flesh and of the costume are the same. The background could be found in the work of any Abstract Expressionist. In this painting, we are saying good-bye to the nineteenth century. Yet is it a work of the same man who once remarked about his creations: "No art is as little spontaneous as mine. What I do is the result of reflection and the study of the Great Masters."

52

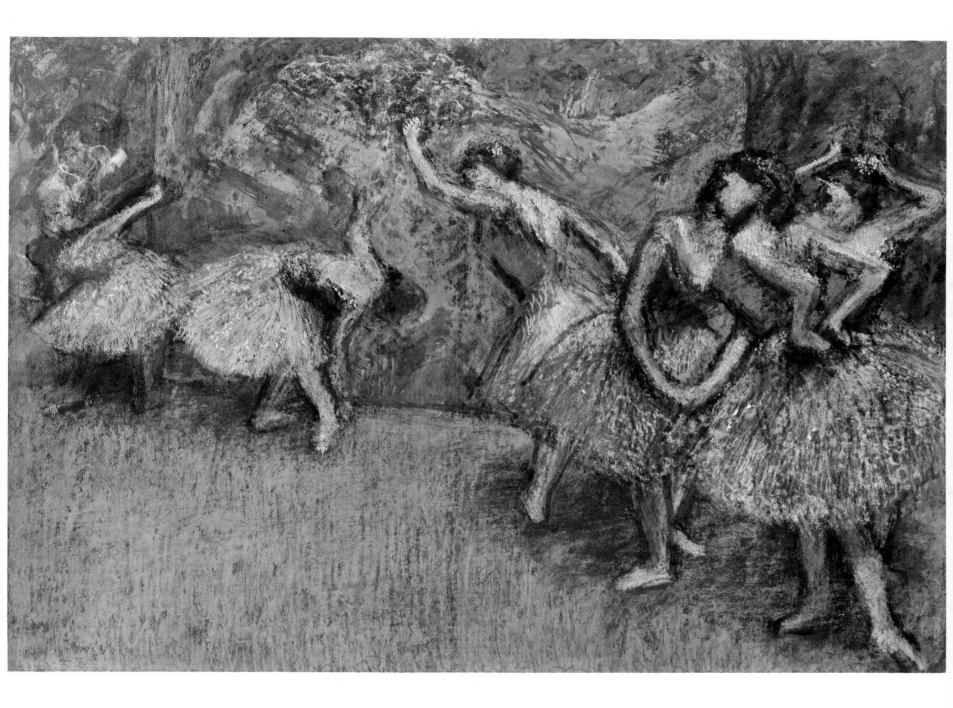

18. THE SINGER IN GREEN

1884. 23¾″ x 18¼″. (60 x 46 cm.)
The Metropolitan Museum of Art, New York, New York.
Bequest of Stephen C. Clark.

This is a performer in a *café-concert* (known in affectionate vernacular as *caf'-con*). The singer here is still young and shows no signs of the vulgarity and moral corruption usually noticeable in both Degas' and Toulouse-Lautrec's renderings of *chanteuses*. While this young lady is not really pretty, she is a beauty compared to her most famous colleague, the scrawny, pinch-faced, unalluring Yvette Guilbert painted by Toulouse-Lautrec. Yvette's specialties were musical obscenities; this singer, however, seems more likely to have had her audience in tears over some sentimental reference to an everyday tragedy.

As is frequently the case in this master's work, the light comes from below, reversing the expected patterns of light and shadow. Note the splendors of color—the henna hair, lemon body, green shadows, blue and orange striped skirt, and the blue-green background which becomes chartreuse as it reaches the right border.

This picture was acquired by a collector in Moscow. When the Soviets expropriated it, the painting was housed in Moscow's Museum of Modern Western Art. There it was seen by a critic who wrote: "The *Chanteuse Verte* brings painting to the expression of music quite as successfully as Giorgione" (*Modern French Painting in Moscow*, International Studio, October, 1930). With many other pictures, it was eventually sold abroad, then acquired by Stephen C. Clark, who bequeathed it to the Metropolitan Museum of Art.

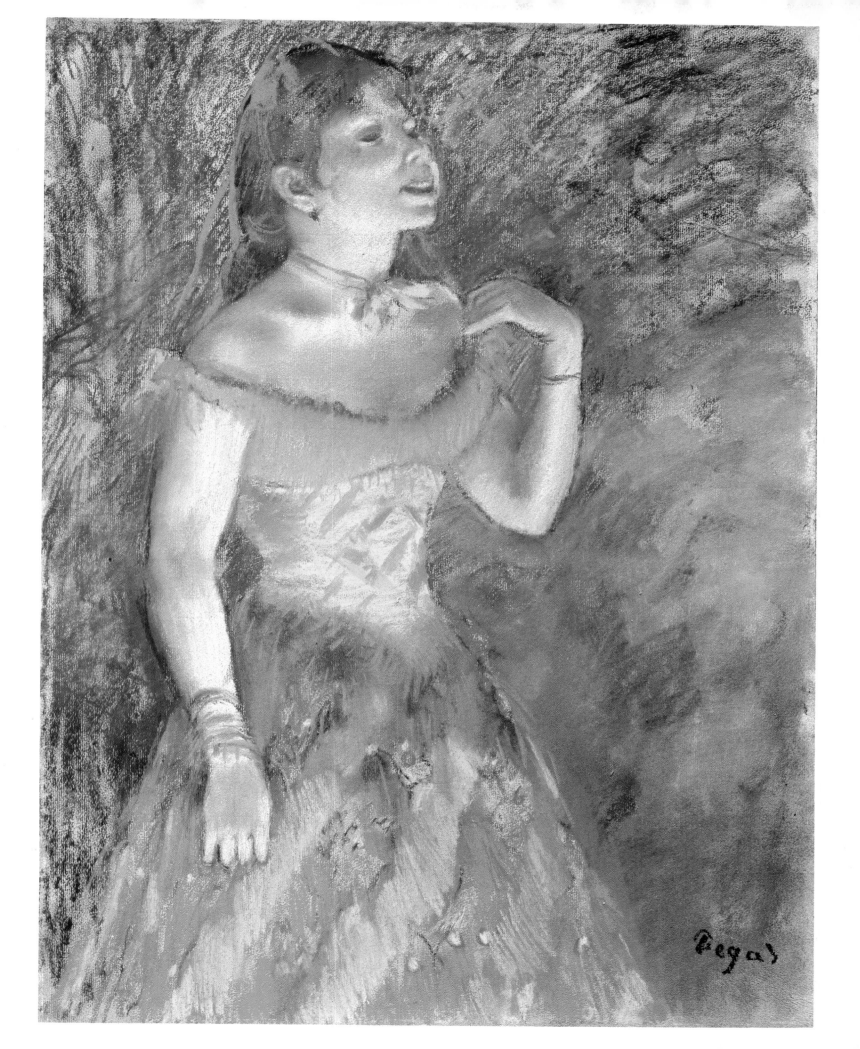

19. CABARET SCENE

1875. 8⅜″ x 16″. (21 x 40 cm.)
The W. A. Clark Collection,
The Corcoran Gallery of Art, Washington, D.C.

This small work is related to *The Café-Concert, Les Ambassadeurs*, a large pastel on monotype in the Musée de Lyon. The Café Les Ambassadeurs, situated on the "good" side of the Champs-Elysées, was already in existence at the beginning of the last century. Open in the summer only, it seated its patrons at little tables under trees, with a stage at one end, and a restaurant at the other. Here such entertainers as Aristide Bruant and Yvette Guilbert enjoyed great triumphs. Most of the people in show business, however, did not rise above mediocrity, and all had to put up with a noisy and unruly crowd that whistled, jeered, and shouted.

Degas depicts the crass banality of the scene. The obese woman, her dark hair pulled tightly back from her coarse face, is probably singing a vulgar song. The artist neither moralizes nor evinces any sympathy for her, but simply shows her thick arms, her protuberant breasts, her bulging, excess flesh. Wretchedness and meanness are there, but Degas was no more an apostle of social reform than was his disciple, Toulouse-Lautrec, also a frequent habitué at Les Ambassadeurs.

Note the dramatic contrast between the shadowy orchestra and the brilliantly lit stage upon which the performers await their turns.

What appears to be a crease running across the upper part of the painting is actually a groove in the paper left by the edge of the copperplate on which the monotype was drawn. In all likelihood, Degas originally intended to end his picture at the plate mark, then changed his mind and drew beyond it in order to extend the composition vertically.

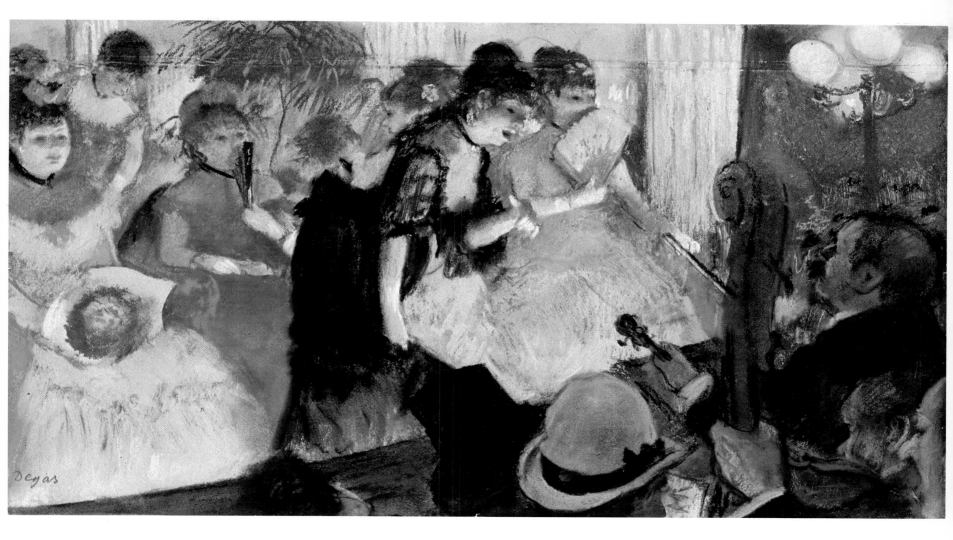

20. BEFORE THE CURTAIN CALL

1892. 20″ x 12½″. (50 x 31 cm.)
Wadsworth Atheneum, Hartford, Connecticut.

An attendant prepares an actress for the moment when the curtain will go up (the yellow disk is a peep-hole in the curtain that allows the performers to watch the audience unobserved). The star pulls on her long white gloves, as the kneeling maid adjusts her train. Neither the form nor the folds of this drapery have been rendered realistically. Nevertheless, the dashing scribble of strokes and the blur of color are placed so knowingly that the viewer easily identifies this passage as the train of a dress. Degas has applied his magic to demonstrate the various effects produced by the gaslight on the chartreuse dress of the performer and on the carpet, ablaze with color. This audacious composition has more solidity and stability than is apparent at first glance. The sumptuous carpet, a wild abstract pattern, might be expected to jump up and overwhelm the comparatively subtle figures. Yet the floor stays flat and the figures rest firmly on it because the strokes—though at war with each other—generally follow the floor's direction. The shadow cast by the standing women helps anchor the two figures to the carpet even more securely.

But this light follows no rules. Unexpectedly, it shines from above upon one arm, from the side upon the other arm, from below upon the face, and from behind upon the neck. Thus, the light sources are completely arbitrary—as, incidentally, are the green shadows on the skin. The composition is astonishing: one might think the artist had climbed a ladder and looked down from it diagonally, in order to view the rather pedestrian subject in the most exotic way.

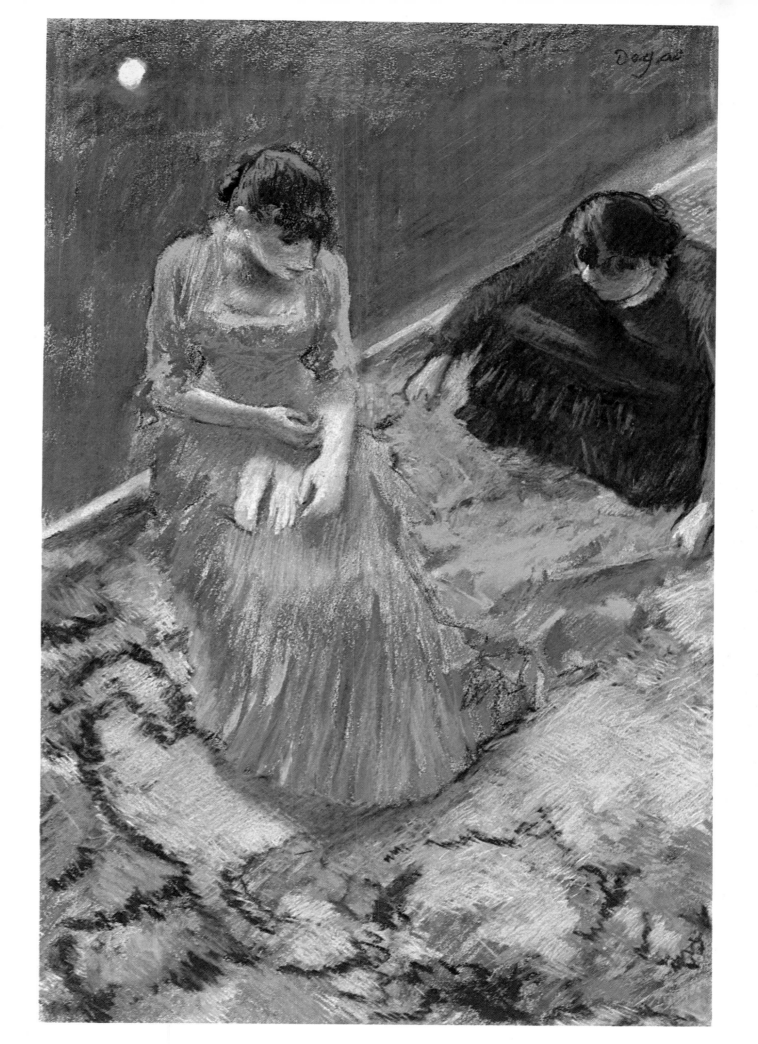

21. RACE HORSES

Ca. 1873. 22⅝″ x 25¾″. (60 x 64 cm.)
The Cleveland Museum of Art, Cleveland, Ohio.
Purchase, Leonard C. Hanna, Jr. Bequest.

Horse-racing developed in eighteenth century England. The French artist Géricault became acquainted with the sport during his stay in Britain (1820-22) and painted a Derby at Epsom (in the Louvre). In France, racing became the vogue under the regimes of Louis-Philippe and Napoleon III. Degas, too, visited England, but it is not certain whether he ever went to the celebrated tracks at Epsom, though two of his paintings are believed to have been inspired by them. He learned to admire thoroughbreds during a stay at the Normandy estate of friends. Four of his pictures are definitely set in Longchamps, where the race-track was opened in 1857.

Off and on, between 1860 and 1900, the world of racing and the elegance of horses fascinated him. It has been estimated that in his *oeuvre* about 45 oils, 20 pastels, 250 drawings, and 17 sculptures are related to these motifs. However it is not known that he ever mounted a horse or ever placed a bet. His pictures have little, if any, documentary value for historians of this "sport of kings," since the artist was not interested in portraying famous jockeys or horses, or even specific races.

Yet unlike his fellow-Impressionists who ignored the subject, he had a surprising knowledge of the world of the "turf." More precisely, he knew all about the wonderful mechanism called horse, the play of its muscles and its intricate movements. And he recorded all of its sudden, and often unexpected, attitudes. Many drawings testify to the fact that Degas was very eager to know horses in anatomical detail.

Rarely are horse and rider represented moving with great velocity in Degas' works. More often, there is a static frieze of four, five, or more horse and rider groups in a green landscape. Frequently, as in this pastel, an asymmetric composition, cleverly contrived, with "premeditated instantaneousness," creates the illusion of naturalness. It is an illusion, for no attempt is made to characterize the faces of the riders, and no shadows are cast by the horses although the day is obviously meant to be bright and sunny. And while the artist knew the anatomy of the animals very well, the horses' legs are organized arbitrarily to make pleasing forms, rather than to record objectively observed reality.

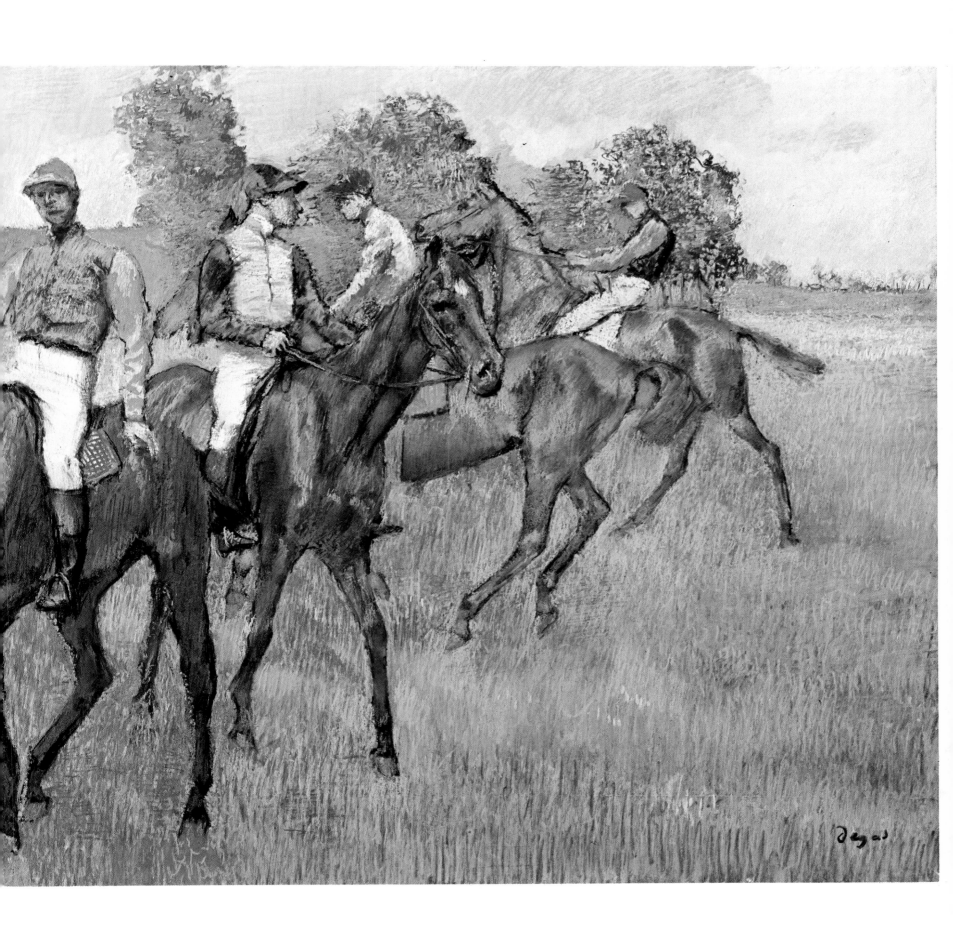

22. LANDSCAPE

Ca. 1890-92. 11¾″ x 15¾″. (29 x 39 cm.)
Museum of Fine Arts, Boston, Massachusetts.
Ross Collection.

Time and again Degas spoke with sarcasm about landscape and landscapists. At a Monet exhibition he turned up his coat collar demonstratively to avoid catching cold, for it was too drafty, he explained with his usual acid humor. His advice to artists was: "Draw what has stayed in your memory, then you'll only bring out what has really struck you, which is all that matters."

This landscape, indeed, contains only that which seemed absolutely essential to him. Inevitably, lawns and trees turn up in Degas' race-course scenes. But they serve only as background, no more significant than the decor in his ballet scenes. He surprised his friends when he showed a series of pastels (over monotypes) at Durand-Ruel's (October 1892 to early 1893). These Burgundy landscapes are slightly blurred visions that appear to have come up from the mists of imagination, in contrast to the works of the Impressionists who—as indicated by photographs later taken on the spot—rarely deviated considerably from the actual image.

To his British colleague, William Rothenstein, he once confided: "I feel no need to go into ecstasy over nature." Two other friends have reported on his strange aversion to nature. The sculptor Albert Bartholomé, with whom he traveled through Burgundy, claimed that he "never once stopped to look." The dealer Ambroise Vollard

saw him working in a room in a country home, with his back turned to the landscape he was painting. Yet the results intrigued so discriminating a connoisseur as Pissarro, who, after having seen the show at Durand-Ruel's, wrote to his son, Lucien: "Degas is having an exhibition of landscapes; rough sketches in pastel that are like impressions in colors, they are very interesting, a little ungainly, though wonderfully delicate in tone . . . these notes, so harmoniously related, aren't they what we are seeking?"

Did the Impressionists really share similar goals? Remember Degas' famous dictum: "The air that one sees in the paintings of the masters is never air that one can breathe." This landscape, in any case, is closer to Turner than to Pissarro. Turner, like Degas, also evolved from a linear to a painterly style, ending up with the virtual dissolution of his subjects into swirls of color. Towards the close of his career, Degas used landscape as a pretext for experiments with color. One may remember Paul Valéry's comment that Degas did his landscapes only "as a flourish . . . not without a certain sly enjoyment at the expense of the open-air fanatics. There was something oddly arbitrary about them; but those which he used as a background to his riders . . . are defined . . . with all the exactitude he loved."

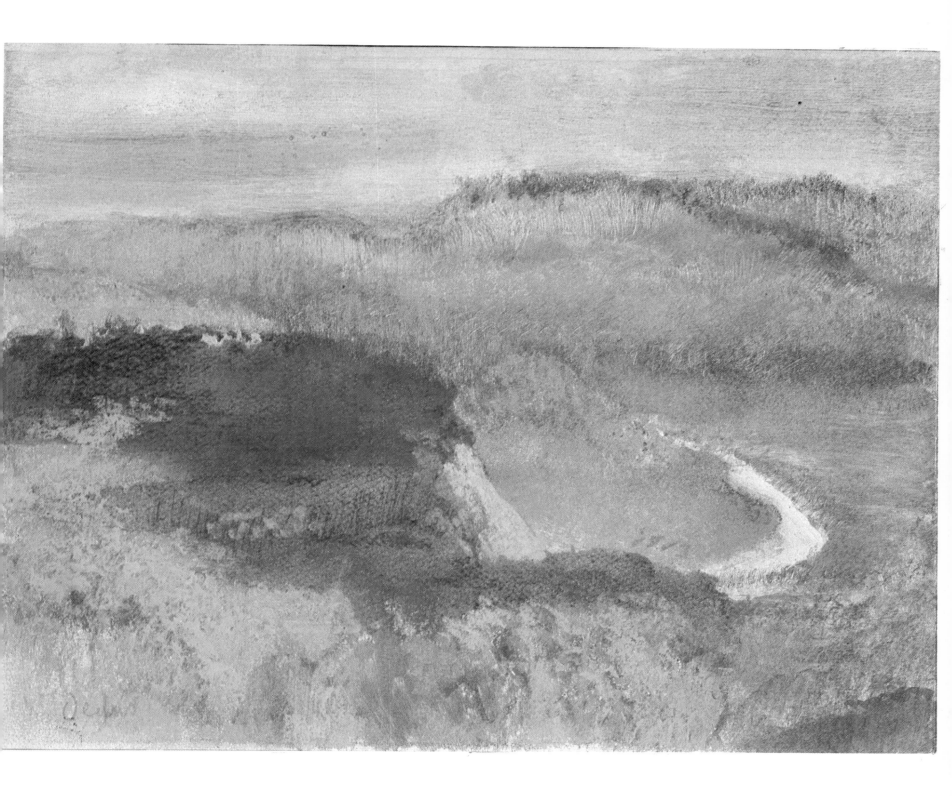

23. AT THE MILLINER'S

1882. 30″ x 34″. (75 x 85 cm.)
The Metropolitan Museum of Art, New York, New York.
The H. O. Havemeyer Collection. Bequest of Mrs. H. O. Havemeyer.

Degas, an avid reader, must have been familiar with Baudelaire's essay, "The Painter of Modern Life," with its shrewd observations such as: "Every fashion is charming, relatively speaking, each one being a new and more or less happy effort in the direction of Beauty, some kind of approximation to an ideal for which the restless human mind feels a constant, titillating hunger." And, "Woman is quite within her right, indeed she is even accomplishing a kind of duty, when she devotes herself to appearing magical and supernatural; she has to astonish and charm us; as an idol, she is obliged to adorn herself in order to be adored."

Though himself without emotional attachment to any particular female, Degas enjoyed accompanying women friends to the dressmaker or milliner. He was fascinated by the play of the seamstress' hands against the rich and bright materials. Mary Cassatt, whom he had met in 1877, is said to have posed for this picture (though her features, in shadow, are hard to distinguish), as she sometimes did when Degas' requirements were too difficult for an ordinary model to understand, and, therefore, to execute.

In this daring composition, the customer tentatively adjusts a new bonnet with one hand and makes a questioning gesture with the other. The *modiste* is half concealed by a full length mirror which audaciously divides the picture in two. The hat in the center (presumably held by the milliner) seems to dangle in space, one of three abstract arrangements of color which furnish lovely focal points of attention.

Unlike the Impressionists, but very much like the Japanese printmakers, Degas often used broad areas of flat color, as he does here in the wall and slanting floor. The effect is based on these broad masses of color (which the artist smudges little or not at all), and on the carefully designed patterns of strokes. The chalk is heavy in the foreground figure, and the strokes dissolve into a crumbly mass on the rough paper. In the background, the vertical strokes are more lightly applied. The background figure is rendered with a pattern of horizontal, vertical, and diagonal strokes.

In *Confessions of a Young Man* (1888), George Moore, who must have seen the picture in the eighth Impressionist exhibition, described the shopper in *At the Milliner's* as being "as typical of the 19th century as Fragonard's ladies are of the Court of Louis XV."

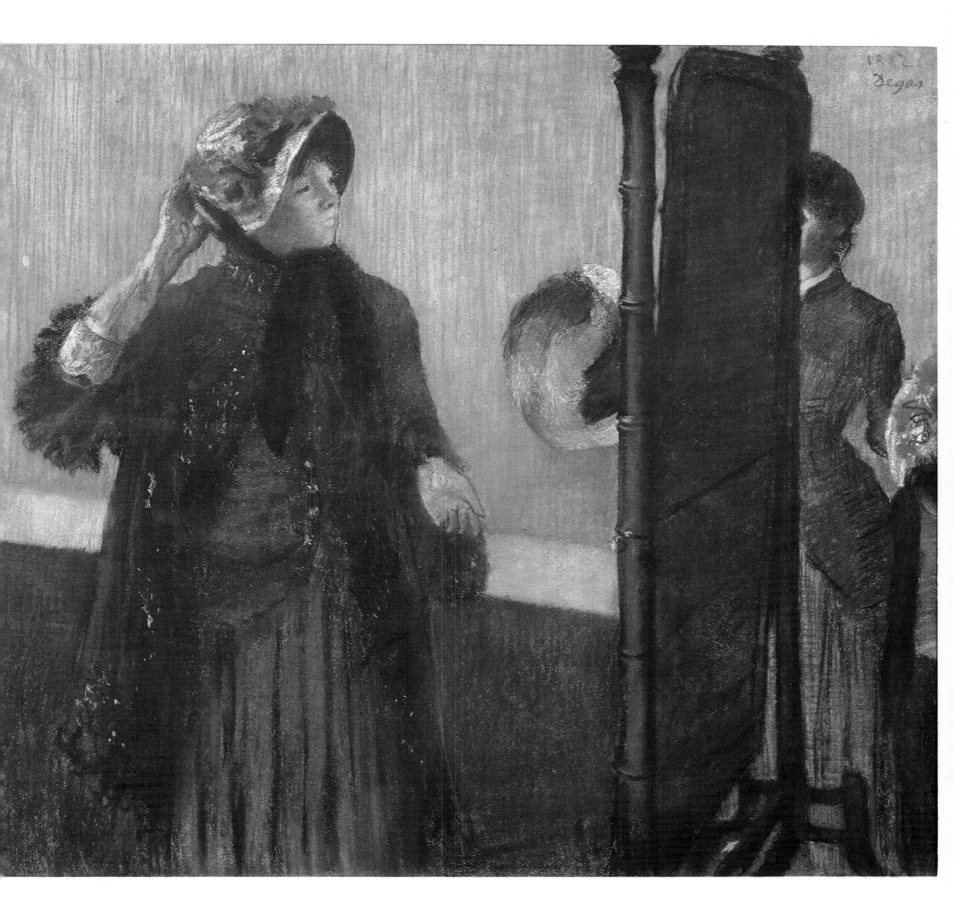

Ca. 1882. 27⅝" x 27¾". (69 x 69½ cm.)
The Museum of Modern Art, New York, New York.
Gift of Mrs. David M. Levy.

The critic Edmond Duranty, whose features we know from one of Degas' finest portraits (now in the museum in Glasgow, Scotland), wrote in his pamphlet, *La Nouvelle Peinture* (1876): "Let us take leave of the stylized human body, which is treated like a vase. What we need is the characteristic modern person in his clothes, in the midst of his social surroundings, at home or out in the street . . ."

This must have been sweet music to the Impressionists and their followers. No nymphs or goddesses for them! Degas' more conservative colleagues would not have cared for such a humdrum theme as this, where the young woman, with her long pointed chin and her tightly compressed mouth—again Mary Cassatt—is seen tying the ribbons of her bonnet with impatient hands. An interesting arabesque is produced by the two hats, held expectantly by the attendant, whose face and body are largely cut off at the left by the frame.

It is curious that this picture should have been chosen to adorn the dust jacket of *The History of Impressionism*, by John Rewald. As one writer has noted, "He [Degas] was never an Impressionist at all." It is recorded that the very Degas who participated in all but one of the eight Impressionist shows could get angry at the mention of the Impressionists. "They ought to be . . .," he said to an acquaintance, aiming his cane as if it were a rifle. Yet while indoor scenes such as *At the Milliner's* did not really belong to the steady repertory of the Impressionists, this picture is linked to them and their philosophy by its spontaneity, its modernity, and its daring, unacademic composition.

This is one of the rare instances in which Degas gives a face individuality and expression. Note the look of amused pleasure on the customer's face and compare this detailed development with the blurred and shadowy shorthand of the attendant's visage. This highly conscious technique of selective finishing is also apparent in the rendering of the customer's hands. The left one, in shadow, is not carried into any detail. The right hand, however, is highly developed, modeled by the light which focuses upon it and which highlights the line of the model's jaw as well. The same light spills onto the extraordinary yellow chair dominating the foreground, and leads the viewer's eye diagonally into the picture toward the major figure. This warm light contrasts sharply with the ribbons and inside curve of the suspended hat, whose dramatic patches of black are abstractly composed.

25. A WOMAN HAVING HER HAIR COMBED

Ca. 1885. 29⅛" x 23⅞". (73 x 60 cm.)
The Metropolitan Museum of Art, New York, New York.
The H. O. Havemeyer Collection. Bequest of Mrs. H. O. Havemeyer.

Degas neither drew nor painted any "Homage to Venus." Nor are his nudes the cheerful, enticing little creatures whom the friendly and happy family man Renoir welcomed to his studio. Apparently, Degas' models were not required to be pretty at all, though the mature, but well preserved sitter in this pastel has a healthy, statuesque body whose opulence would have pleased so discriminating a critic as Rubens.

The artist once sighed: "See what difference time has made— two centuries ago I would have painted Susannah at the bath!" Actually, while biblical and historical themes are not absent from his work, Degas soon recognized that they were not for him, that he could render only what he could observe (this alone relates him to the Impressionists).

He viewed his models as an animal keeper might study his caged creatures. To him, they were chattels rather than women, scarcely distinguished from the horses he observed at the race tracks. He dethroned the idealized woman of the Classical painters and offered us, instead, "a cat licking herself" (his own words), giving us a glossary of all the conceivable, rather banal positions and expressions of a woman grooming herself.

This is a more finished picture of a nude than is usually found among Degas' pastels. Though rather late, it is still a very realistic work, in which the strokes, carefully placed, follow cylindrically around the form. The arms blend into the background, the hair melts into the shadow, but the edge of the right breast remains sharply defined.

Deliberately, the figure of the maid is cut off just above the bosom (her skirt is simply a flat surface with just two or three folds). The flow of white unites the two figures, and the diagonal of the yellow tufted *chaise longue* (often used in his pictures) harmonizes with the equally rich yellow background.

This work, as well as *Woman Drying Her Foot* (Plate 27), is believed to be among the ten pastels (a "series of nudes of women bathing, washing, drying themselves . . . combing their hair and having it combed," to quote from the catalogue) that were shown in the eighth and last Impressionist exhibition (1886). There are several works by Degas on the theme of this particular pastel. Douglas Cooper remarks that "the present picture is rather an exception in the hairdressing series because in most the action of combing is presented as something of a struggle."

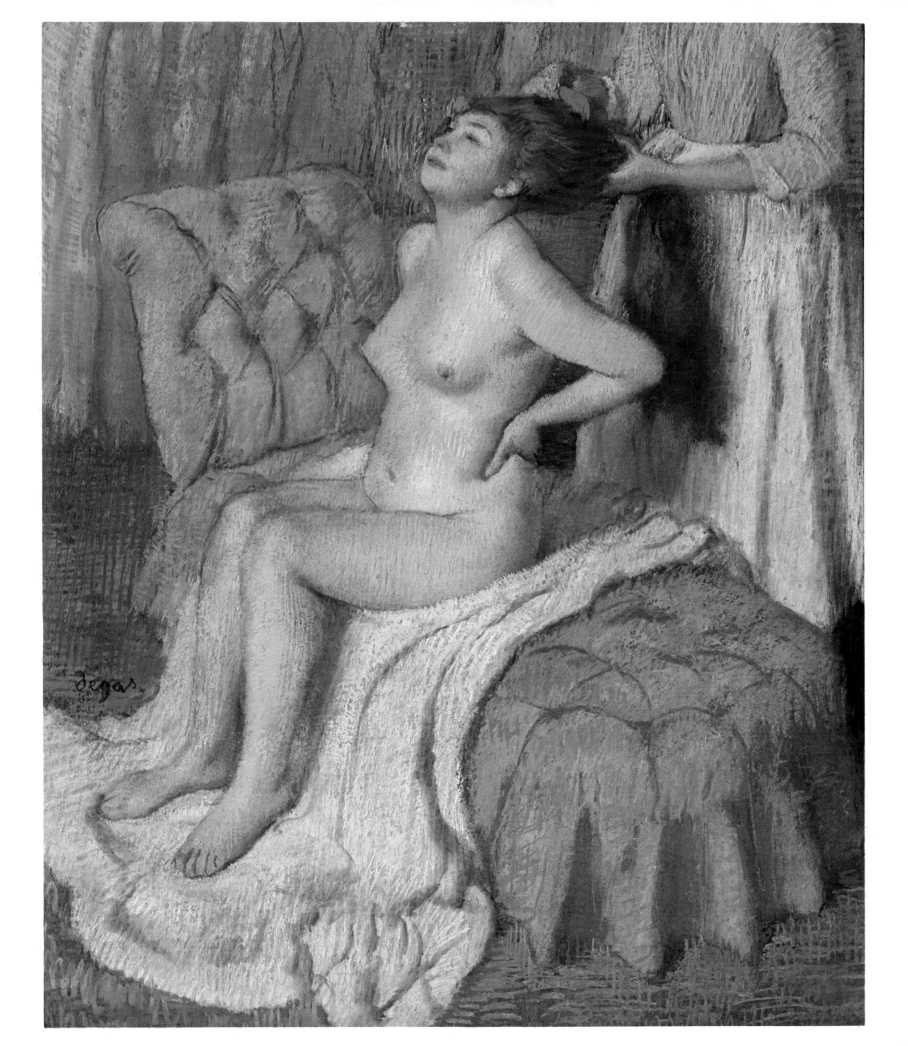

26. THE TUB

1886. 27½″ x 27½″. (70 x 70 cm.)
The Hill-Stead Museum, Inc., Farmington, Connecticut.

Some of Degas' bathers are seen entering or leaving large tubs not very different from those used today. But these were a rarity in nineteenth century France. Families were more likely to own large round portable basins such as the one here. This shallow tub forced his models into contortions—and thus brought into play muscles which ordinarily might not have caught the light. As a matter of fact, Degas "discovered" in women a muscularity which most artists before him—from Pollaiuolo to early nineteenth century artists—had thought confined to men. In classical art, the female nude's muscles are nearly always concealed under a padding of fat and an immaculately smooth skin.

Here, the sitter's face is not visible. Our attention is drawn to the rhythmic movements of her shoulders and arms, to the juxtaposition of circular and angular forms. The critic J.-K. Huysmans must have had pictures like this in mind when he deplored Degas' "unique emphasis on the hateful or the contemptible." If a man of Huysmans' culture and advanced ideas was shocked, what could one expect of the less sophisticated art lover, conditioned to accept only the impeccable nudes, whose well proportioned bodies were made socially presentable by mythological disguise! At the same time, Huysmans had the courage to defend Degas against the charge of obscenity: "Never before have works been so lacking in slyness or questionable overtones. They even glorify a carnal disdain as never since the Middle Ages an artist dared to do."

To observe this pose, the artist must have stood on a chair and looked down at his model (somewhat the way the aged Pissarro painted Parisian street life by looking out of a window thirty or more feet above the ground). While this "plunging" view of the model is in itself a bold departure from tradition, even less conventional is Degas' use of color. Here, the artist has defied traditional methods of color perspective which dictate that the brightest colors be used in the foreground, the softest in the background. The blue of the background curtains is quite as intense as the blue of the foreground tub. The tones of the drapery on the floor and behind the model's torso are in the very same key as the tones of the window. Yet Degas has nevertheless created a convincing feeling of depth, space, and light without rigidly applying traditional color principles.

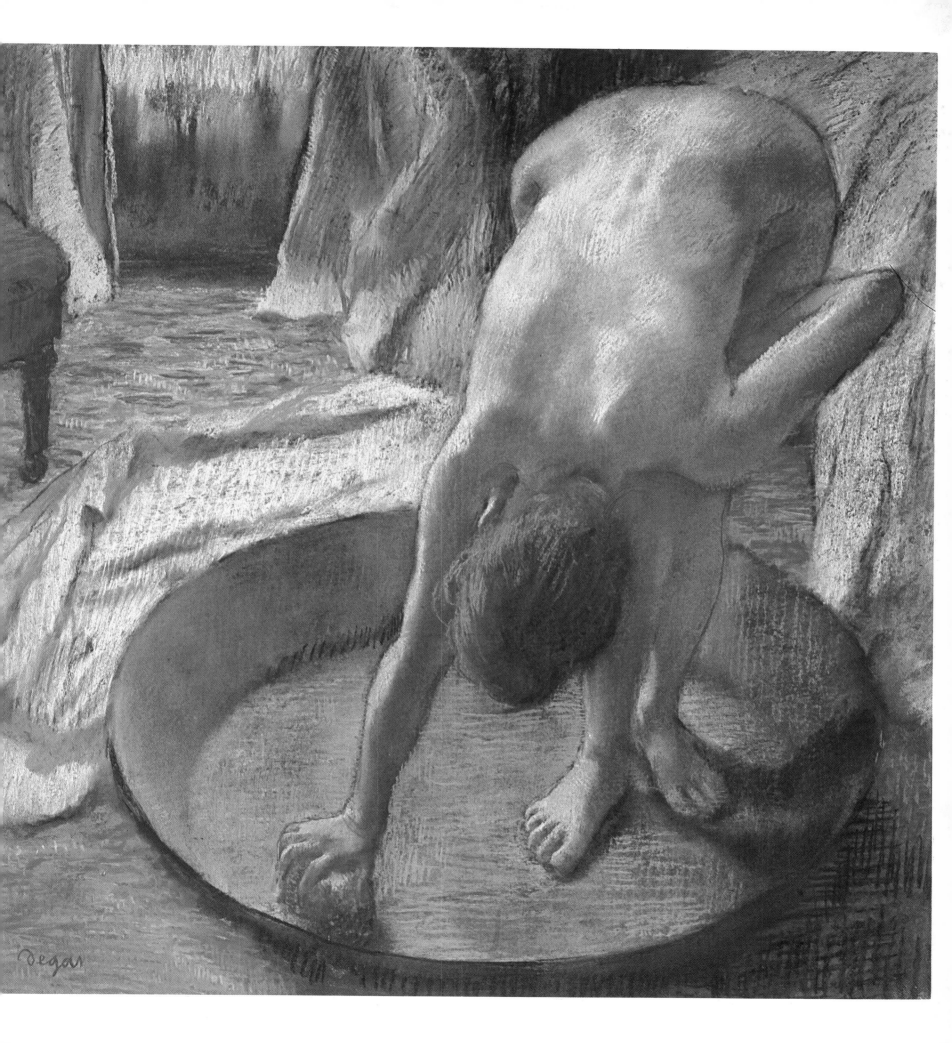

1886. 19¾″ x 21¼″. (49 x 53 cm.)
The Metropolitan Museum of Art, New York, New York.
The H. O. Havemeyer Collection. Bequest of Mrs. H. O. Havemeyer.

This pastel, formerly called *After the Bath*, is related to *Nude Drying Her Arm*, also in the Metropolitan Museum. It is hard for us to understand the moral indignation of the Parisians in the 1880's (a period in which bordellos flourished as never before) toward art such as this. Curiously, nobody objected to what Henry James called the "conscientious nude"—Bouguereau's presentations of decorous females which always have something slyly indecorous in their movements or facial expressions. Yet his creations hung in the drawing rooms of bankers, industrialists, and politicians who would discuss them "scientifically" after the ladies of the party had withdrawn for a conversation of their own.

But Bouguereau's precise nudes failed to hide from Degas and like-minded artists their underlying pettiness and poverty of spirit. These nudes, without a wrinkle, without breath, inner structure, or organs, were too pink and soft, too spineless and slick to command the admiration of a truth-seeker like Degas. As one of his younger colleagues, Théophile-Alexandre Steinlen, remarked about the marvelous correctness of academic work, "When everything is perfect, nothing is perfect."

Degas loathed popular "graceful poses," and liked the unpremeditated action of his models engaged in ablutions and personal care. He was as fascinated by their movements as he was by horses, or by the heavy and rhythmic gestures of laundresses wearily pushing their irons.

One can imagine how academic painters felt when they saw a picture like this, in which so unusual a pose is struck that it might be hard to find one as daring in the entire repertory of drawings and paintings of the nude. In this pinwheel body, the contour is full of surprises—edges harden, soften, disappear, and reappear, as the line unfolds.

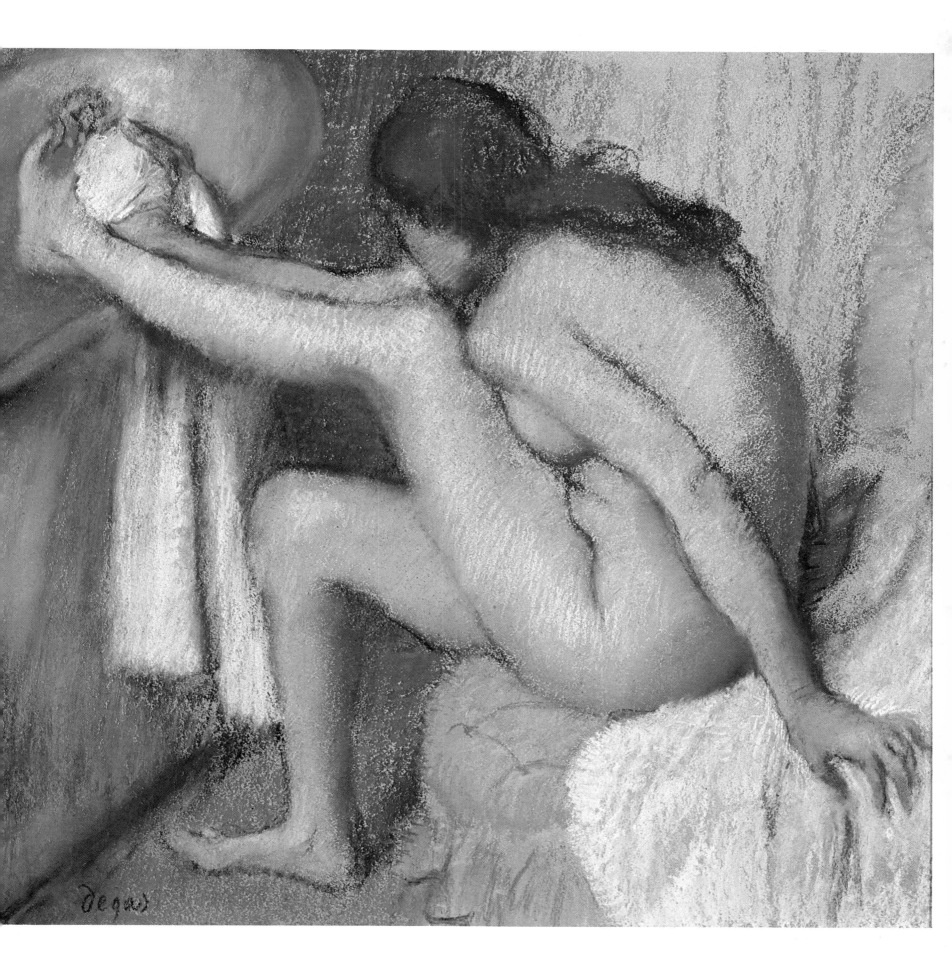

28. THE MORNING BATH

1890. 27¾" x 17". (69 x 43 cm.)
Art Institute of Chicago, Chicago, Illinois.
Potter Palmer Collection.

This picture was produced a quarter of a century after Manet's *Olympia* had created such a scandal at the official *Salon* that it had to be guarded by policemen to protect it from the assaults of visitors. By now, *Olympia,* that "parcel of filth," has become a classic painting and even Renoir's nudes seem to us a trifle too pretty. Yet in the 1870's one critic angrily wrote: "Just try to explain to Monsieur Renoir that a woman's torso is not a heap of decayed flesh, green and purple spots signifying the state of complete putrefaction in a corpse." One wonders what the same reviewer would have said about the nudes Degas created when he was past the age of fifty. . . .

Perhaps there are some people left who prefer the early, more academic works of the master to the late ones, with their vibrancy of color, expressive vigor, and forthright honesty. But it must be hard now to find an artist of any school who would not bow in reverence before them. In his time, Degas was revered largely by the Impressionists, by Gauguin, and by such younger colleagues as Forain, Toulouse-Lautrec, and Suzanne Valadon. Undoubtedly, Bonnard is heavily indebted to him "in the adoption of awkward placing, angular motifs and abrupt cropping to create a vivid and unexpected equilibrium of forms" (James T. Soby, as quoted by John Rewald in *Pierre Bonnard*, 1948). Bonnard, too, watched his models at their toilette and at rest. But even more than similarity of subject and approach, it is the glorious, glowing colors here which most anticipate Bonnard's paintings. In both this dazzling work and Bonnard's sun-flooded canvases, the nude is coloristically so integrated with the room that she becomes part of it.

Such a work would almost fit into an exhibition of starkly contemporary figure painting. All contour has disappeared. The head is just a blob of brown. The inside curve of the body is but a luminous blue abstraction. Most of the foreground area is taken up by the big, amorphous drapery. Note the unexpected touches of orange-yellow which weave through the greens and blues, heightening their intensity.

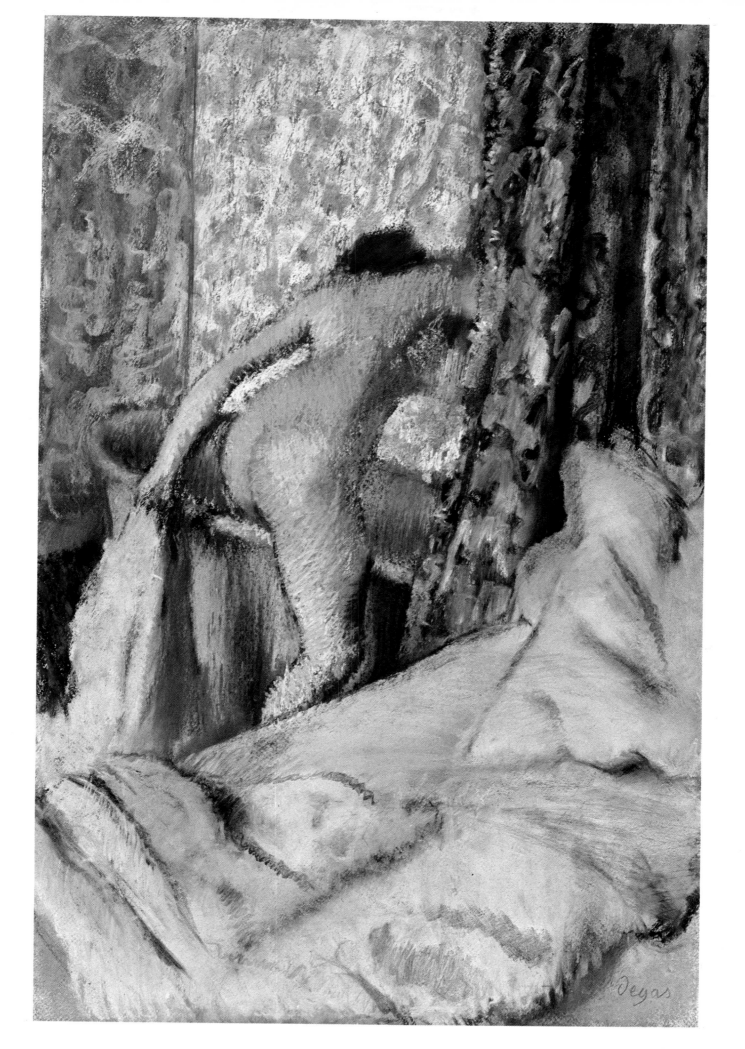

29. AFTER THE BATH

Ca. 1895-98. 30″ x 32½″. (75 x 81 cm.)
The Phillips Collection, Washington, D.C.

Already a middle-aged man when he composed this pastel, Degas endeavored to emancipate the nude from the academic tradition. Abandoning the refinement of careful outlines noticeable in his early work, he portrayed the *bête humaine* by means of intense colors and volumes, preserving just enough realism to make the incredible appear probable—in other words, just enough to keep the composition from being abstract (in the modern sense of the term *abstract*).

In this daring work, the subject is broadly suggested, but nowhere carried into detail. The nude is almost entirely in shadow, except for the line of light which curves down her arm and links it to the drapery on the right. Anatomical fidelity is incidental in the strangely contorted form of the nude, and the attendant has neither face nor hands. Drapery, tub, and background are "Expressionist" abstractions. Subject has become an excuse for coloristic and formal experimentation in which all objects—human or inanimate—are of equal significance. Color is applied in wild, scribbly strokes, in dots and dashes, and built up thickly with fixative to create impasto effects.

Degas achieves these effects at the expense of traditional beauty, for the woman here is hardly what the average man would consider attractive. Still, it would be wrong to assume, as has been done, that the artist Degas painted what the philosopher Schopenhauer verbalized when he labeled woman the bandy-legged unesthetic sex. For Degas, subject was largely a peg upon which to hang splendid workmanship. And if the postures of some of these girls are far from enchanting, we must not allow them to obliterate the memory of so many charming creatures in his thousands of drawings and paintings, especially his renderings of young dancers and singers.

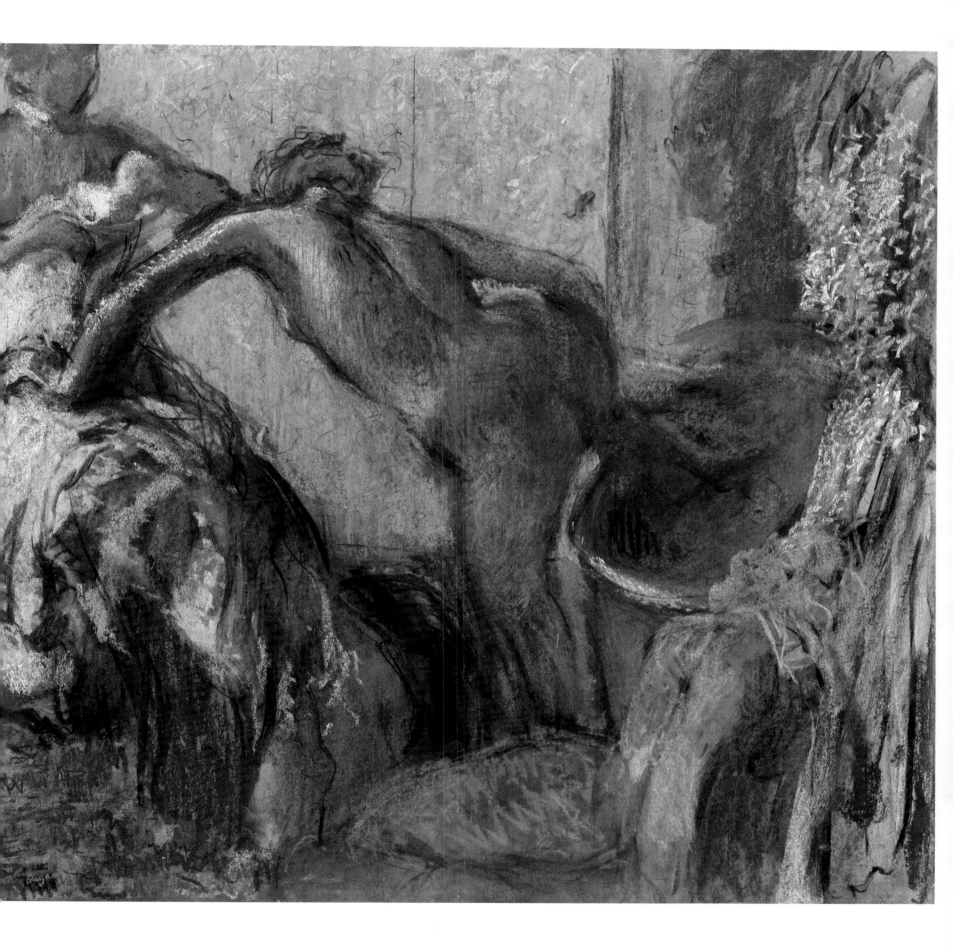

30. NUDE

Ca. 1885. 31¼″ x 22½″. (78 x 56 cm.)
The Columbus Gallery of Fine Arts, Columbus, Ohio.
The Ferdinand Howland Collection.

In his search for unedited poses and surprises of furtive nakedness, Degas went further than anyone else of his century. Rejecting the merely lovely, the merely pleasing, he served up the nude, as one writer put it, like a trussed animal on a common platter. He avoided sentimentality and emphasized his disinclination to become emotionally involved with the model. No sensual pleasure is expressed here, as it is in the nudes in Delacroix' historical painting, *The Death of Sardanapalus*. No pagan feeling is present in Degas' work as in Corot's nymphs. Nor was the artist very choosy about his model. He did not care if she was dumpy and unattractive. Edmund von Mach complained that Degas, drawing or painting nude women, "sees only their form; their soul life does not interest him, for he cannot see it with his physical eye, and his soul seems to have been created blind" (in *The Art of Painting in the Nineteenth Century*, 1908).

But the anonymity and impersonality of the model had a great advantage for Degas. He could construct and reconstruct her with unparalleled freedom, without any concern for conventions, for any personal message except one of a strictly aesthetic nature.

In his artistic emancipation, he plunges the figure into red shadows and lights her arm, shoulder, and hip with mauve. Only a corner of one ear is distinguishable in the nude's head. The upper background has a thick, smeary quality, as though the greens and yellows had melted into each other. A bright, pure patch of red is dashed arbitrarily into the lower left hand corner to liven up the blue. Confronted with final works like this, it would be absurd to talk of "pastel shades"—with reference to the traditional tonal softness of this medium.

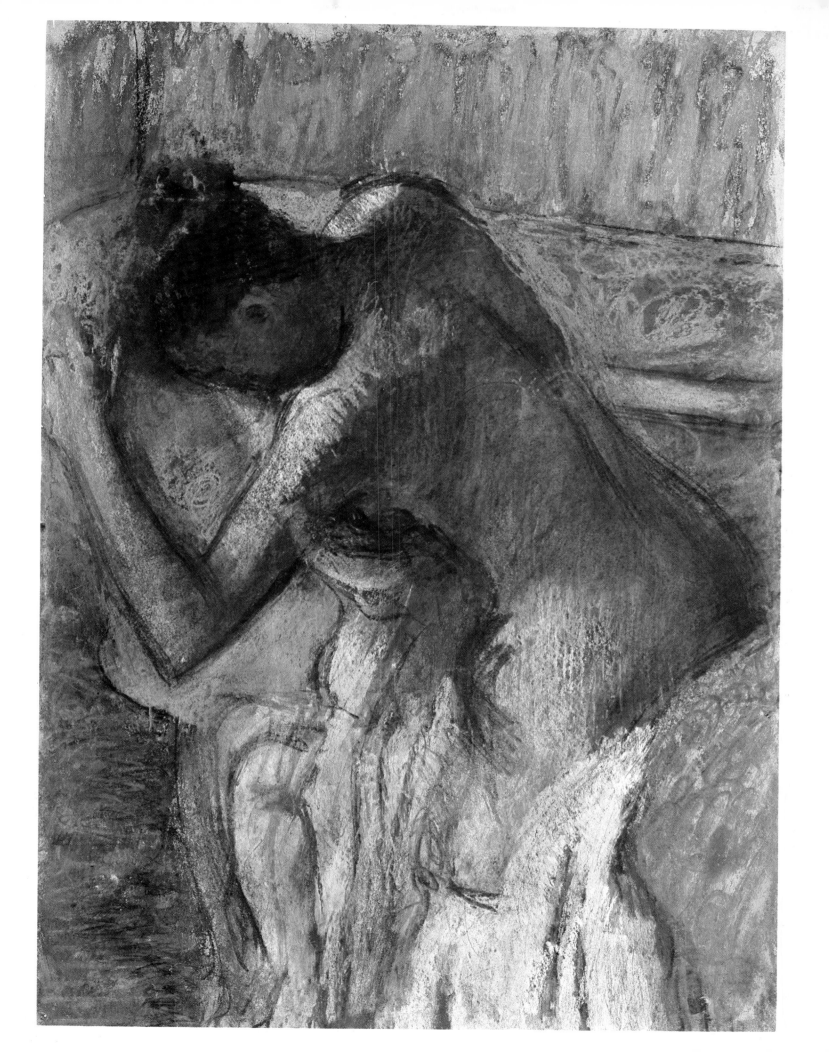

31. AFTER THE BATH

Ca. 1890-96. 28" x 22⅝". (70 x 57 cm.)
Fogg Art Museum, Harvard University, Cambridge, Massachusetts.
Gift of Mrs. J. Montgomery Sears.

Degas' contemporaries, Bouguereau and Cabanel, for their patrons' delectation produced nudes which seem to be made of pink and white marble. To treat the nude as Degas did—as a *Comédie Humaine*—was an affront to all standards of his day. But his sole aim was to record positions and actions that allowed him to invent new patterns suggested by the ordinarily unobserved and private gestures of women. He constantly looked at his models from a fresh angle and always rejected the slavish imitation of nature.

Note how Degas has treated the towel. Its shape, fanning in a semi-circle around the figure, is a highly original interpretation of reality. Notice, too, how Degas again violates all the rules of color perspective. Instead of placing the strongest colors in the foreground, the softest in the background, he manipulates planes of color—without reference to their intensity—to create depth. For example, the green-orange used in the foreground drapery and the background wall (which, incidentally, is crosshatched like a swatch of roughly textured fabric) are of equal intensity. The towel and the tub, though presumably at different distances from the viewer's eye, are coloristically very similar. And the cluster of intense red and blue clothing at the upper left hand corner is the brightest object in the painting—yet it is placed in the background plane. Degas has created a most convincing sense of depth and space, not by gradation of tone, but by overlapping the various forms and alternating the colors in which each is painted to create seven distinct visual planes.

Kenneth Clark, who considers Degas the greatest draftsman since the Renaissance, explains: "His subject was the figure in action, his aim to communicate most vividly the idea of movement; and he felt that vividness of movement must somehow be expressed through shapes that convince us that they are complete in themselves" (*The Nude*).

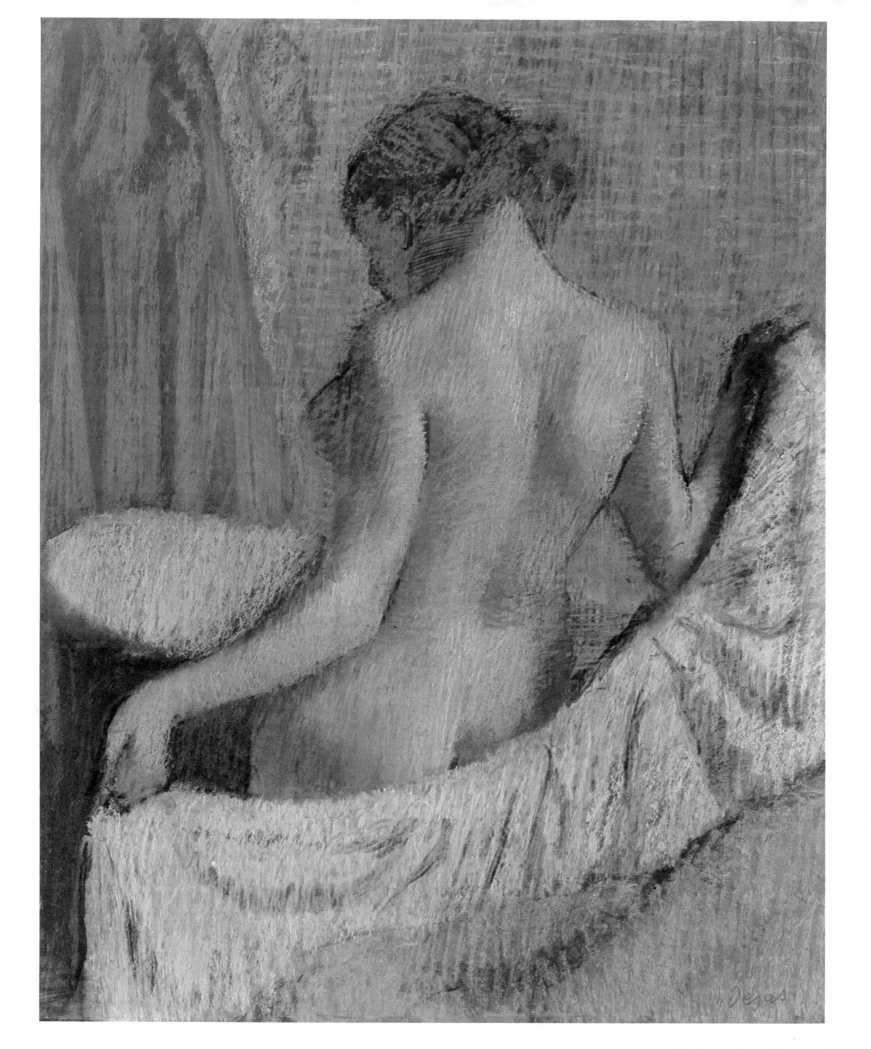

32. WOMAN AT HER TOILETTE

After 1900. 29 7/16″ x 28⅓″. (74 x 71 cm.)
Art Institute of Chicago, Chicago, Illinois.
Mr. and Mrs. Martin Ryerson Collection.

"*Voilà l'animal!*" Degas once explained in front of a picture like this one. In Western art, there are tens of thousands of renderings of the female nude. A display of over a hundred academic pictures of nudes, done by *Beaux-Arts* professors and their docile students, would be a bore. Degas wanted to shock the eye out of its routine of seeing. He succeeded in doing this by the refreshing rudeness of his art that has its counterpart in his caustic comments, which are still quoted with delight by all who endorse growth and change.

By 1900, his eyesight had become very poor, but instead of diminishing his qualities as an artist, this hindrance led him to a new monumentality, a greater simplification and freedom of line.

But his is not line *à la* Ingres. From the precise drawing of his early work, line has evolved into a painterly tangle of scribbles crisscrossing through and beyond the form and sacrificing it to color. Except for the spine and left upper arm, the figure is drowned in a churning sea of color.

Toward the end of his life, Degas often used much more lavish color in his foregrounds and backgrounds than he did in his central figures. This tendency is particularly evident in this pastel where the subtlest form in the entire painting is the nude figure itself.

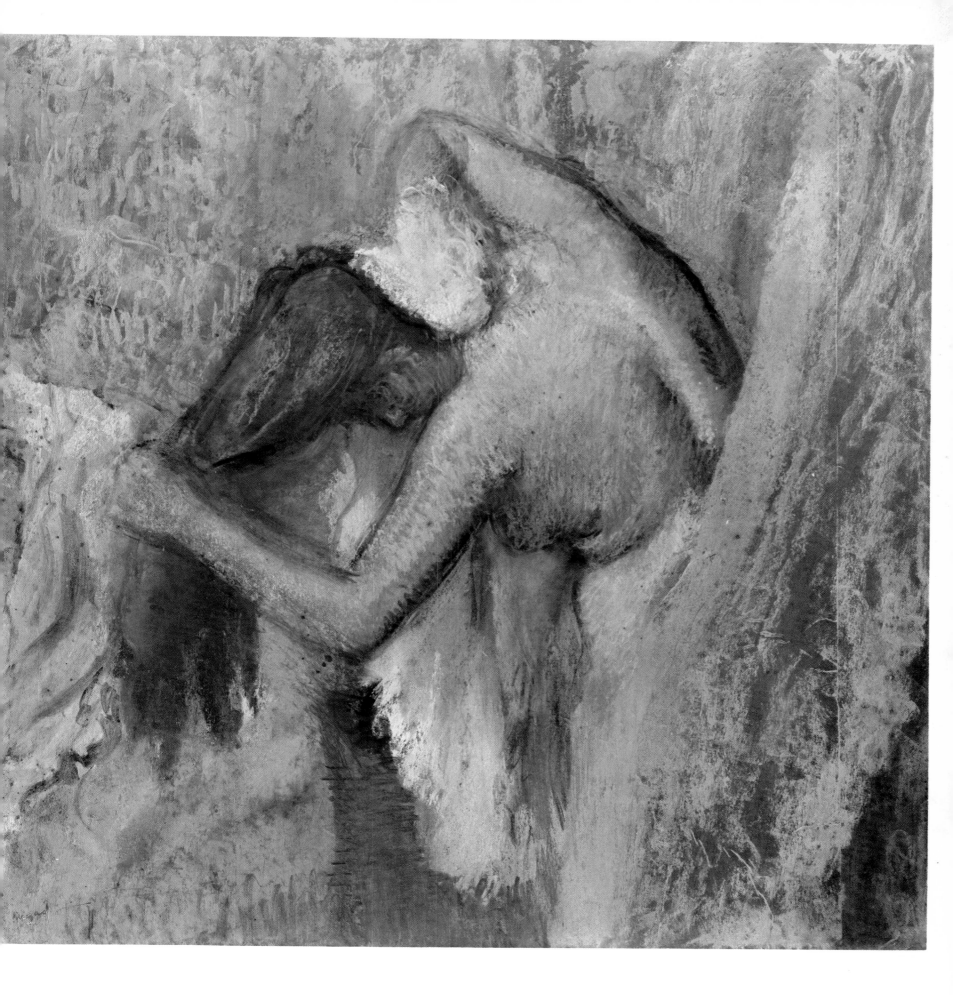

Selected Bibliography

Boggs, Jean Southerland, *Portraits by Degas*, University of California Press, Berkeley and Los Angeles, 1962.

Boggs, Jean Southerland, *Drawings by Degas*, Essay and Catalogue, City Art Museum of St. Louis, 1967.

Bouret, Jean, *Degas*, Tudor Publishing Co., New York, 1965.

Browse, Lillian, *Degas Dancers*, Faber & Faber, London, n.d.

Cabanne, Pierre, *Edgar Degas*, Editions Pierre Tisné, Paris, 1958.

Charensol, Georges, *Degas*, Harry N. Abrams, Inc., New York, 1959.

Cooper, Douglas, *Pastels by Degas*, The Macmillan Co., New York, 1953.

Fosca, Francois, *Degas*, Skira, Geneva, 1954.

Guérin, Marcel, Editor, *Degas Letters*, Bruno Cassirer, Oxford, n.d.

Gammel, R.S. Ives, *The Shop-Talk of Edgar Degas*, University Press, Boston, 1961.

Halévy, Daniel, *My Friend Degas*, Wesleyan University Press, Middletown, Conn., 1964.

Huettinger, Edouard, *Degas*, Crown Publishers, New York, 1960.

Janis, Eugenia Parry, *Degas Monotypes*, N.Y. Graphic Society, Greenwich, Conn., 1968.

Lemoisne, Paul-André, *Degas et Son Oeuvre*, Brame et de Hauke, Paris, 1947-49.

Mauclair, Camille, *Edgar Degas*, Hyperion Press, New York, 1945.

Pecirka, Jaromir, *Drawings by Degas*, Peter Nevill, London, 1964.

Pickvance, Ronald, *Degas' Racing World*, Exhibition Catalogue, Wildenstein & Co., New York, 1968.

Pool, Phoebe, *Degas*, Spring Books, London, 1963.

Rich, Daniel Catton, *Degas*, Harry N. Abrams, Inc., New York, 1951.

Rouart, Denis, *Degas à la Recherche de sa Technique*, Floury, Paris, 1945.

Valéry, Paul, *Degas—Manet—Morisot*, Pantheon Books, New York, 1960.

Index

Edited by Judith A. Levy
Designed by James Craig
Composed in twelve point Bembo by Howard O. Bullard, Typographers
Printed and bound in Japan by Toppan Printing Company, Ltd.